AUDLEY

THROUGH TIME

Tony Lancaster

AMBERLEY PUBLISHING

1 A question of organisation

You can be the speediest bloke in the world. You can have muscles like skyscraper blocks. But none of that will stop you being the world's biggest dunderhead. I've lost track of the lads I've met who had everything that they needed to become ace bike riders . . . except for an ounce of organisation.

We've all done it once, of course . . . but they made a habit of it: they'd turn up without their shoes, they'd forget to post an entry form, they'd muff their gear change in the finishing sprint, or (my own favourite trick) they'd wear too little on a cold day and stifle themselves in extra clothing once it got warmer. They'd also always leave home about 20 minutes too late, so that they missed their start at a time trial or got into a heated conversation with the commissaire at a road race.

There's a book called *Cycle Racing: Training to Win* which will give you the strength, speed and skill that'll set you on the right path. The job now is to teach you to be not just a potential winner, but a champion. That doesn't mean that I was either; I learned the hard way. I'm a failed racer.

My most regular cycling mate was a bloke called Duncan. I suppose I was 20 and he was a few years older. We neither of us drove, let alone actually owned cars, and we travelled everywhere by train – something he found cheaper than I did because he spent half his nights in a signal box.

Duncan organised my race entries and towards the end of each week I'd find a start sheet delivered to my home during some moonlit ride back from his night shift. On it, apart from details supplied by the race organiser, were extracts from the British Rail timetable and an Egon Ronay-style collection of assessments against each rider's name – exclamation marks instead of stars.

Once, when we'd entered an event on a hilly circuit in Surrey, he recognised one of Britain's Tour de l'Avenir riders that year.

'There is only *one* Ken Cotman, I suppose?' he'd scribbled plaintively alongside the dreaded man's name. I forget if Cotman won. I know Duncan didn't and I know I certainly didn't, because I never did.

More clubs need blokes like Duncan because to me he was worth his weight in gold. It's now only my very great hypocrisy which lets me urge you to be organised while remembering at the same time that I depended wholeheartedly on Duncan.

Still, it's not just chance that the best riders don't turn up without their racing licences. And I can tell you from my experience as a race organiser that they don't send their entries late, either. Because races are won long before they start, by a methodical, organised, almost clinical approach.

Some winners are more clinical than others. Once on a Youth Week training course in London, I challenged that year's junior road race champion with my view that he raced only for the money. He was flabbergasted.

'I was two pounds out of pocket by the time I got home,' he stuttered, genuinely offended.

There are a great number of national championships and it's been my view for some years that it's so that everybody can win at least one during a career. The really determined can win several during a season. When, in the magazine *Cycling*, I once reprinted my friend Duncan's seriously-held view that there should be a national third-category title, I wasn't mocked but taken seriously by at least half a dozen letter writers.

Road races, track, time trials and cyclo-cross appeal to different riders. Their temperaments and their physical build are often quite different. It's all very well saying it's all one wonderful sport, but the truth is that it's every bit as varied as athletics, with the trackies resembling the shot-putters, the time trialists being like marathon runners, and the roadmen having the gung-ho outlook of steeplechasers.

Hardly surprising, then, that clubs sway towards one or the other. My first club was horrified that Duncan and I chose to ride road races rather than time trials, and the old Guinness drinkers at the bar maintained polite but uninterested relations. My next club, by contrast, still regretted that the BLRC had disappeared and it raised no small sum by selling BLRC lapel badges. It did, though, support time trialling as well, and promoted an annual cyclo-cross.

The club you join depends mainly on where you live. They're fairly heavy on the ground in cities but uncommon in country areas, which reflects the way that cycling began as a sport for toffs and developed as a relaxation for city dwellers escaping to the countryside. Libraries keep lists of local clubs and societies, or you can get one from the BCF (which will send you a list of BCF-affiliated clubs – and therefore RTTC-

affiliated clubs, since that's the way it goes). Or best of all, you can make contact through your nearest *real* bike shop.

Look for somewhere describing itself as a *lightweight* shop. The owner will probably be a club member himself and, if there's a choice, he'll point you in the right direction.

The best clubs have a good coach or, at the least, helpful senior advisers. By no means all of them do, though, because bikies join clubs to race and not necessarily to advise others. Some clubs have two or three coaches; sometimes the coach will also be racing. There are lists of coaches in the BCF and RTTC handbooks with, in the BCF handbook, a guide to the parts of the sport in which individuals specialise.

Qualified coaches have to pass examinations set by the coaching council. Before the coaching scheme started about 20 years ago, there were no end of self-appointed coaches who sometimes did an excellent job, sometimes hung on to ideas that Frank Southall would have found familiar yonks ago. Just a few simply needed their heads testing.

Use a coach to help you choose races and set objectives. For all the splendour of having so many championships, there's no point in entering one if all you'll get is your entry back – usually too late to enter anything else. Aim to make your season progressive, so that you improve. Set yourself targets but be realistic; you can't win the Tour de France on a six-week training schedule. Remember that professionals not only train more, they also rest more. So be adventurous, but be realistic. Get yourself into a team, as well.

Now, bike racing teams aren't formal affairs like football or volleyball teams. It's not even essential to form one. The advantages are that road race organisers, for some reason, prefer them, and time trial promoters often give prizes to them. The ideal number is three, all of about the same age and ability, all living close by, and all wanting to ride in much the same races.

Choose a team secretary or captain or whatever – someone to take charge and make last-minute decisions when the rest of you aren't around. Set common objectives, choose the races you want to ride for at least the next six weeks and pay the secretary your entry fees and a little extra for postage. The secretary then addresses an envelope to each race organiser, writing the name of the race in the top left corner and the last day of posting where the stamp will go.

The posting date is more important than the day of the race because closing dates can vary. It's also the last day on which he can accept your completed entry form. For road races, where you have only to list your best performances in previous and current seasons, you can normally complete and sign a handful at a time; in time trialling, entry forms are

like income tax returns and have to be completed at great length, race by race. You have to do it, so make sure that you do.

Knowing whether you've been entered, therefore, is just a case of checking whether your secretary's still got the envelope. If he hasn't, you've been entered.

Shrewd secretaries can cut a lot of corners. You may all be travelling to a time trial in the same car, for example, in which case it's not unreasonable to ask to be placed fairly close in the starting order.

The commonest distribution is to put the fastest off at 120, the second fastest at 60, third fastest at 110, fourth at 50 and so on through the tens, then arranging the fives and then working through to the nines. The idea is to stop the best catching the next best and turning the race into a massive handicap road race. On the other hand, if you're not a trio of world-beating stars, there's not a lot of harm done by making slight amendments. You'll certainly appreciate it if the alternative is to be set off at numbers, 8, 104 and 116; you'll all have to turn up two hours early for number 8, and he'll have to wait two hours for you to get back at the end.

Equally, do ask for a late start if you've got a long way to go. The old idea of getting an obliging landlady to put you up near the course and have her sheets stained with embrocation and her sleep disrupted by your nocturnal thumpings has, probably at the impetus of the landladies, disappeared. So ask for a late start rather than travel half the night. The organiser might oblige, he might not.

Actually, for many years, anybody with an ounce of sense asked for a late start because there was a greater emphasis on running time trials on so-called drag strips, where the traffic blew and then sucked you along as it passed. The traffic was heavier for the later starters, hence the requests. The RTTC now looks less favourably on busy courses. The busiest have been banned, either totally or at the worst periods, such as Saturday afternoons.

A secretary for road race entries makes sense because road race organisers send start sheets (or returned entries) in bulk to just one member of the team. Who he picks is a whim of his own, so the secretary can either write his address on all the entries or add a note saying where he wants the details to be sent. Just putting one address prevents even the dimmest organiser going astray.

Nobody knows why road race organisers favour teams. It may be a hangover from the time trialling era, where team awards were common (again for no more obvious reason, since team racing is just what *isn't* allowed in time trialling) or it could be a fond hankering after events like the Tour de France, in which teams play a great tactical part. If it is the Tour that they're trying to re-create, it seems a pretty vain notion in your

average thirds-and-junior 40-miler. Still, if they want teams, let them have teams.

The order of selection in a road race is not a science. The very best races go solely on quality. But the rest follow a pattern like this:

First, the organiser finds all the entries from riders in the highest eligible categories. If his race is for first, second and third categories, he'll take the first-categories and as many of the rest as he can to make up a full field. He smiles on those who have won races that season (especially division championships, which sound important even though they're often among the easiest events of the year), those who've had the symmetry to enter in teams, and those who've ridden his races before. He immediately hooks out those from clubs that don't promote their own road races and those from clubs that *do* but wouldn't accept his own entry earlier on.

You have to enter a time trial in advance and on time. Late entries aren't accepted. You can enter some road races on the day simply by turning up, but it's unpredictable and often more expensive. Anyone with serious ambitions will enter in advance and, only when an entry's been rejected elsewhere, try for a late ride on the line.

Same-day entries are common on the continent but they're new here and the rules can vary each year, so it's worth checking.

Cyclo-cross, on the other hand, bothers with advance entries only in important races. Nobody gets turned away.

I've left track racing to last because the one-time lion of the sport has been reduced to a whimpering pup. Track racing has been reduced to little more than mid-week league meetings run as an adjunct to road racing. There are very few riders who'd call themselves track specialists.

Track leagues are collections of clubs sharing the promotions between them. Some leagues attract great numbers, but you can ride only if your club's affiliated (there's a similar system in time trialling). Each league has its own rules for entering, usually very informal. Real open meetings, held mostly on bank holidays, are entered in much the same way as a road race, although the entry form is more complicated.

2 On the day

It may be that you've got this far still feeling baffled how the sport works. So, just in case, and before we get on to the main purpose of the chapter, here's a quick run through of who's who.

The principal championships are offered by three bodies: the British Cycling Federation, the Road Time Trials Council, and the British Cyclo-cross Association. You don't *have* to understand what each of them does, and why they don't all just get together, but it might help you realise what a marvellously eccentric sport you've got yourself interested in.

The British Cycling Federation

The BCF represents Britain nationally at the world association, the Union de Cyclisme International, and sends teams abroad that do, in general, rather poorly. It draws up the rules for road races (massed-start events, where the first man across the line is the winner) and for track meetings (races on superior running tracks, where the turns are banked for higher speeds).

This was a job done for many years by the National Cyclists Union. There had been a belief for many years that British cyclists ought not ape their counterparts on the continent by racing in big bunches on public roads. The only time it had been tried, rather nearer to penny-farthings than now, the police and sundry others had objected and cycling had taken fright at the prospect of being banned.

The NCU, therefore, had concentrated on track racing. The track, for many decades, was very popular and the few massed-start events were held in parks or on motor-racing circuits and were regarded as novelty events. Few is certainly the right word because for ages and ages there

were none at all, and there was great rejoicing (and subsequent disappointment) in the occasional summers that the UCI decided to hold the world championship events against the clock (which we fancied we were good at) rather than *en ligne*.

Around the Second World War, though, a handful of enthusiasts in the Midlands became discontented at all this and, sensing that times and attitudes had changed, ran massed races on the open roads. Cycling held its breath and waited to be outlawed. The NCU denounced the rebels, insisted that they were putting the whole sport at risk (cyclists have always been paranoid about their place on the road, even before the First World War), and had nothing to do with the new troublemakers.

The troublemakers, though, thrived and set up the British League of Racing Cyclists. There were more and more road races. There was more and more dispute. Clubs favoured one or the other, with one side being depicted as loutish and the other as appallingly stuffy.

It's not rare for other countries to have rebel organisations and the BLRC co-operated with them, sending teams to multi-day races in France and, occasionally, to legitimate races. This upset the NCU even more and at one time the UCI became so cross that it looked like Britain might be excluded from international racing until it sorted itself out.

The disagreement flared right through the Second World War and out the other side. Only in 1959 did an armistice come, and the NCU and the BLRC merged to become the British Cycling Federation. There are still those who say it's more like the old NCU than the more vibrant BLRC.

Unlike the other bodies, it has a permanent national office with paid officials – a fact which contributes, perhaps necessarily, to the relatively high cost of road and track races. It also does a lot to prevent just one body running the sport.

The Road Time Trials Council

Racing alone (or occasionally in teams) against the clock is a very mathematical business. You can't go claiming you were the 25-mile record holder if your course was a few yards short or the watch a dicky bargain retrieved from a pawn shop. There has to be organisation in these things. And if any body reeks of organisation, it's the RTTC – cycling's equivalent of the Rotary Club, attracting unusual proportions of accountants, water board officials and school teachers.

The RTTC since the start has established order and standardisation and resisted change. The most famous story goes back to the days when ancient road-scorchers scattered chickens in country lanes and upset

parsons. The RTTC ruled that the remedy was secrecy: races were to be held at dawn, between nowhere and nowhere, on courses identified only by code numbers. Even the cycling press couldn't say when and where races were to be held. Dates were given as weekend numbers and starting instructions were headed 'private and confidential'. No numbers were to be carried.

These men undoubtedly had sincere motives, but their oddest rule was that every competitor had to dress from neck to ankle in black. This was to dissuade rural insomniacs who witnessed up to a hundred and twenty of these black wraiths hammering along for all they were worth that there was some sort of race in progress. The all-black rule disappeared with the war, but the private and confidential business lingered for years. By that time road races were garish affairs drawing big crowds, so the secrecy had become a joke.

The same clubs affiliate to the RTTC as affiliate to the BCF. Each year, at the BCF annual meeting, they tell the BCF to amalgamate with the RTTC. Then, a few weeks later, they tell the RTTC to resist amalgamation, citing among reasons the BCF's overheads in maintaining a permanent staff and sending teams abroad.

In desperation, the BCF was finally instructed to authorise time trials under its own rules, but again the cost of buying a licence made sure the RTTC's grip wasn't weakened.

The British Cyclo-cross Association

The idea of crashing through the mud on your bike isn't new. What *was* new was the idea of setting up a sport with as few rules as possible. You can do that when you start off as an organised skylark and determine to keep it that way, so that everyone can take part and some can take it seriously.

The BC-CA began, really, as individual areas which became keen on cross-country racing. The most enthusiastic were the Midlanders, who to this day dominate the sport. It was in the south, though – in London – that the groups got together to form a national association.

It's autonomous but, learning from the experience of setting up rival organisations (and wanting no trouble from the UCI when it came to picking teams), the BC-CA is a body within the BCF.

The great joy is that the sport runs smoothly despite this peculiar top layer. The same men might not run all three organisations, and their personalities are quite different, but at least they talk to each other. You, as a bikie, only need to know how to work the system.

This is that clubs affiliate to the BCF, the RTTC, the BC-CA and to such local allegiances as they choose. With the RTTC and the BC-CA, there is no further formality. With the BCF – and this is the time trialists' big objection – there most certainly is. Having joined your BCF-registered club, you yourself then have to join the BCF as an individual. Then, as though paying twice wasn't enough, you have to pay a third time by buying a racing licence. The total cost mightn't be much compared to a golf club and a year of gin and tonics, but it does mean that road racing is more expensive than either time trialling or cyclo-cross.

Whatever the race, you're only putting yourself at a big disadvantage if you turn up late. Turn up early and you can look at the course, go over the instructions, figure out who's starting and who hasn't turned up. It gives you time to build up the adrenalin – the chemical that gets your heart beating faster and your lungs going ready for a big effort.

If you travel by car for any distance, especially for a morning start, it's pretty easy to do it with the heater on and the windows wound up. Who wants to freeze in the mist? The trouble is that you arrive half asleep. The drowsy sensation is increased by a nervous reaction – a temptation not to get the bike off the roof rack. It takes a big dose of adrenalin to overcome it. You might not manage it.

Make a point of travelling in your race clothes with a clean, smart tracksuit on top. Don't go, like one '25' champion I knew, in an oily old tracksuit used for training and maintenance; you'll look and feel like a scruffbag and the bloke driving the car won't thank you, either. If you want to be a star, act like one.

Turn the heater just high enough for comfort, open the ventilation and turn the radio on to something poppy. You probably know that the speed of music has an effect on how you feel, but I bet you never guessed how much.

When they buried old Mohammed V in Morocco in 1961, they played funeral music for hours on the loudspeakers. The crowds endured hours of its slow, insistent rhythm and before long there were up to a thousand people an hour being taken to first aid posts in hysterical trances.

I don't suppose Moroccan funeral music has much place in your cassette collection, but you might like to note that between 120 and 140 beats a minute produce mental excitement which will last for hours, and that 180 beats or more a minute will cause excitement but make you tired. Not for nothing do the people who sell canned music study the science of it all. And not for nothing did the old dancing marathons of the 1920s manage to go on for so long.

The boffin I always turn to in cases like this is Dr Peter Travers, from

Exeter University. He wrote about a German colleague called Hess and a part of the brain he called the ergotrophic centre, which is its telephone exchange of sorts.

> He found that when this area was stimulated . . . it caused an output of work found only in panic reactions. One reads of the work capabilities of people in times of panic; of women who lift incredibly heavy weights when the lives of their children are threatened. Similar work outputs can be obtained by stimulation of the ergotropic centre.
>
> It is reasonable to suppose that the regular and insistent rhythm of pop music stimulates the ergotropic centre, thus increasing the work capability of the individual . . .
>
> The thalamus [home of Hess's ergotropic centre] is an important switching centre on the sensory pathways. When it's stimulated . . . the sensory effects of fatigue will be suppressed.

So, rock on, brother!

Time was when folk rode to their overnight digs the day before the race and changed their wheels in time for the morning. Then they'd get up in the darkness, stain the landlady's sheets with embrocation, and ride off looking for the start. What ended the tradition, I'm not sure, but I think it may have been the landladies. It could've been the car. But even now, it still pays to stay overnight near a race if it's particularly important to you and the alternative is hour after hour up or down the A1 (soon to be featured in the *Shell Guide to the Most Boring Roads of Britain*). Remember that it takes your body at least two hours to wake up properly. Organisers will sometimes book somewhere if you ask.

Whether you travel or stay, it's important to spend the previous day wisely. By all means go training if the event doesn't mean much to you – if it's early season, perhaps, and you're riding just as part of your training programme. But otherwise take care. Your legs have been working hard all week and they're entitled to a bit of rest the day before an event. Keep warm, eat well, and keep your legs raised whenever you can. Don't walk around more than you have to. Use your bike if you have to go somewhere, and ride gently in a low gear.

It'd be a shame to take all that trouble and go all that distance to find you've left some crucial bit at home, so make a check list to keep in your kit bag. You'll need:

- Racing shorts, racing vest, undervest, white socks, cycling shoes, braces
- Track mitts, crash hat, old newspaper (for extra insulation)

- Racing licence, spare handkerchief, spare long-sleeved jersey, safety pins
- Details of the race, maps, money
- Track suit and soft shoes
- Embrocations and olive oil, eau de cologne (for removing embrocation)
- Towels, soap, shampoo
- Food and drink for before, during and after the race
- Dustbin liners for soggy, filthy clothing.

If you do have to travel a long way, take turns sitting in the back seats, which are always more crowded and less comfortable than the front; people in the back are also more likely to feel travel sick, because they can't see the road ahead. They're also more likely to be bombed by the bags you've piled up by the back window, every time you jam on the brakes at roundabouts. So take turns.

Get to a road race, track event or cyclo-cross an hour before the start. Make that half an hour for a time trial, or a shade less if you're one of the first ten starters (get to the average time trial half an hour before the first man away and you won't find a soul there).

At a road race, get your bike checked immediately. Helpful officials will be on hand to fluff your gear changes and wrench your saddle loose. If they succeed, you have at least got time to put things right.

If for some reason you've arrived unchanged and you've travelled with a non-rider, get him to take your bike through the check while you change. That's one less thing for you to worry about. Once you're changed, stay where you are until your helper arrives. Don't go running to and fro, because you've only got so much energy inside you and you'll waste a lot by nervous fretting. Your helper will eventually bring confirmation that your bike's been approved – a cloakroom ticket, perhaps, or just a tick on a list. Now go and sign the starter's sheet.

At the same time, look to see whether your main rivals have also signed on. Now take your bike, check exactly how long you've got and where you're expected to collect for the start, and warm up. Include the finish stretch in your warm-up. Ride it slowly and then at speed; notice which way the wind is blowing, particularly if it's an off-circuit finish. Look for landmarks at *your* estimation of 200 yards; don't rely on where somebody with short or ultra-long legs will pace the distance.

If you've come with a coach or a friend and you know you want to hit the front with 120 yards to go, point out where you want him to stand. He'll be more use there, where the crowd is thinner, wearing something prominent or shouting loudly, than on or beyond the finish line.

Now ride back up the course and look for a landmark at half a mile to go. There should be a board at the last kilometre, but never rely on it. Never rely on anything that you could check for yourself.

Actually it's no bad idea to drive the whole circuit on your way to the race headquarters. It's an even better idea, if it's not too long and you're not too late, to ride it. There may be stretches of bad road you want to avoid, or the approach to a hill you want to study. Of particular interest are the half-flat stretches which separate climbs from the descent. They're excellent grounds for attacks.

Time trials have none of the formality of road races, but timing is much more important. Get your bike ready immediately and check your watch with the timekeeper's. He won't thank you for interrupting him, but you can see whether your watches are running together by checking the time at which he sends riders away. Now find where the numbers are kept and see whether the riders immediately ahead and behind you on the start order have arrived. If they have, they will have collected their numbers. Take your own number and go for a warm-up. Take careful note of which way the wind is blowing, and ride a few miles shadowing an earlier starter, perhaps a hundred yards behind him. Don't let yourself get used as a stepping stone by a faster starter behind you; keep checking over your shoulder.

Time your warm-up so that you get back to the start just long enough to take off your tracksuit. Look again at which number is starting and ride up and down until there are 30 seconds to go. Go immediately to the timekeeper, let the pusher-off catch you, and your warm-up will have merged into your race. Never get into the queue that sometimes forms at the start.

Greet the timekeeper and the pusher-off with a polite good morning, but say no more. Stare at the road ahead, will yourself into the race, position your pedals so that one crank is parallel with the down tube, and wait for the traditional countdown.

By the way, if several of you have travelled together, leave the car key somewhere obvious – hidden on the car (underneath, perhaps) or left with the tea wagon. You'll all fall out with the last man in your team if he takes the key with him and you have to wait wet and cold for an hour while he completes the circuit.

Similarly, never carry the keys with you in road races. They're exceptionally painful to fall on.

The procedure for a track race is to arrive an hour before the start. There'll be checks just as there were for a road race, but the warm-up session will be longer. That's important because there'll be no chance to warm up on the track once racing's started.

Track warm-ups are usually a long string of riders in what looks like a ten-miler, with the better riders going straight to the front, where they know the lesser lights aren't going to send them flying. A few tracks run small pacing motorbikes – dernys or mopeds – to pace the warm-up line; a few really dedicated types bring a road bike to potter on in the track centre, although the advantage may be one of solitude rather than physiology.

Cyclo-cross is much less formal. All you've got to do is get there on time. What you ought to do, though, is arrive with time to ride the course several times, decide whether you want to wear running or cycling shoes, whether your range of gears is right (the usual problem is a stretch of firm road which calls for a gear of virtually road-pace proportions).

The problem with arriving in plenty of time is that only the biggest races will send you start details if you enter in advance. Cyclo-cross deliberately keeps itself simple, so the most you'll get are the references in the BC-CA handbook of 'Whippendell Woods, Watford' and perhaps a shade more detail in the diary pages of *Cycling Weekly*. It's a Catch 22 situation because organisers use the same courses regularly, so you'll get to know them, but you can't know them if you don't know where they are.

Just leave plenty of time, look out for direction arrows that the organiser might have thoughtfully put up, and watch for other bikies who seem to have confidence in where they're going.

Once, you'd have had to change in the woods where you rode. Now you can expect changing rooms. Changing rooms have addresses, so all should be well.

And now for a plea: the odd thing about bike races is that they're always the wrong way round. Schoolboys need much more organising and care than older riders, and yet they're always put on first, when the course is still being marked out, the man with the changing room keys hasn't turned up, and not all the officials have arrived.

Then, when their race is under way, they have to contend with riders warming up for the later races. For their sake, please don't. If you have to, take very great care to move aside with plenty of room and in plenty of time to let each competitor pass. It's all very well to assume that you can outpace a schoolboy bunch if you're in a more senior category, but it's very distracting and dismissive to ride along just ahead or, worse still, in the middle of a group of young riders. Would you like it?

Warming up

For years, folk didn't agree about warm-ups. Of all the paperwork I've amassed from boffins the world over, the most varied is about warming

up. I can give you learned treatises that suggest they're a waste of time and energy; there are others that warn of dreadful injuries if you *don't* warm up.

A lot of these contradictions happen because the big-wigs aren't thinking of cycling; they're thinking about more violent games, like rugby and even running, where muscles and joints are twisted and worked to their extreme. In cycling, of course, there's little chance of muscle strain in that sense because your bike keeps you from going into extremes: you can't straighten your legs, arms or back, let alone wrench them, because the handlebars, saddle and pedals keep you in a foetal crouch.

Warming up for cycling, therefore, is simply an anticipation of the effort. That effort will raise your internal body heat – your core temperature – by two degrees and your skin temperature by ten degrees (Fahrenheit). That's why it's called warming up. Other changes follow. For every degree that your body temperature rises, your muscle metabolism increases about 13 per cent. Oxygen flows into the blood more easily, electrical messages travel through the nerves faster, and the adrenal gland pumps a fluid which will stimulate your nervous awareness, increase muscle tension and make your heart beat faster.

To the best of my knowledge, nobody's ever tested racing cyclists immediately before a race. There have been plenty of tests in laboratories, but the effects aren't necessarily the same as in real life – they might be, but they might not. So far as anyone can tell, the benefits of a warm-up that's energetic enough to raise a sweat will last 20 to 30 minutes. On the other hand, the greatest benefit is within 10 minutes and, according to some scientists, as little as 5 minutes.

Randolph Miller did his experiments on runners rather than cyclists, but he was concentrating on endurance athletes rather than sprinters, so the link with cycling looks strong. He got his runners exercising on a treadmill for 8 minutes, let each of them rest for 5, 10, 15 or 20 minutes, then ran their legs off. The warm-ups and the final run were all balanced by separate calculations of the runners' fitness.

From his base at Winona College in America, he said:

> The physiological benefit of moderate warm-up deteriorated rapidly after 5 minutes of rest . . . The increase in recovery interval time beyond 5 minutes following moderate warm-up produced the 'cooling' effect familiar to track and field circles. The best performance, occurring after the 5-minute recovery period . . . enabled the subject to perform more of his tasks aerobically [in which the body can take in all the oxygen that it needs] . . . In addition, the 5 minutes of recovery could have permitted the beneficial temperature

effects to plateau without any accumulation of blood lactate, thus resulting in improved performance.

Now, since there's no exact rule, and since warm-ups will depend on the temperature and probably even your weight and age, and since you can't warm up to within 5 minutes of anything but a time trial, you're going to have to do what you think best. But the principles are worth remembering.

They're particularly worth remembering before a cyclo-cross, for two extra reasons. The first is that cyclo-cross means running, and that means a crude strain on joints and muscles that doesn't happen in conventional racing. The other is that 'cross is very much a skill sport, and skills (bike handling, and all that means) are sharpened by practice.

After the race

Hammering yourself silly on a bike raises your internal temperature, as you've seen. It also raises skin temperature. But you can cool your skin quickly — and there's the problem. If you cool off by hanging about, or worse still by lying on cold pavements or damp grass, the contrast between inside and outside becomes more than your body can stand. You develop a chill. So put on warm clothing, whatever the weather, and carrying on riding. If that sounds odd, there's a good reason.

You go better after a warm-up which starts gently, gets brisker, and then slows down. The race continues that pattern. After easing and stopping, you begin racing. But the end of a race comes suddenly. Your brain knows the event's over, but the muscles can't be sure. They're still packed with hot blood rarin' to go, and stuffed with burnt sugars and carbon dioxide, and probably with lactic acid. If you put on a tracksuit and ride gently for some miles, you'll let your blood vessels close down gradually. It'll also keep your blood flow up, which'll get rid of the toxins faster.

Your body's at fever pitch, your muscles are drained, your brain is weary. Wrap up well once the race is over.

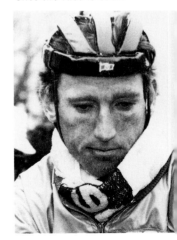

If, on the other hand, you just stop, get changed and stand around, the blood pools in your legs. The blood vessels will still be dilated but your heart won't be pumping the blood about. It's got to go somewhere, so it ends up where gravity sends it — to your legs. The toxins that get stuck there will give you stiff legs.

If you *can't* go for a ride, lie or sit somewhere with your legs raised. Make gravity work for you for a change.

Other hints:

- Brush your teeth daily; visit the dentist frequently. Tooth infections can lead to boils far from your teeth;
- Have a bath or a shower after racing or training;

— Pay particular attention to the bits of you that touch the saddle; never wear racing shorts twice without washing them; don't use creams and potions; don't wear underwear if your shorts or training bottoms have chamois lining; don't wear clothes which'll put an overlapped seam (as distinct from a flat seam) between you and your saddle; be wary of cheap saddles that combine plastic with a softer covering – the covering can become imperceptibly loose under your weight and ruck up;

— Clean the inside of your shoes as well, with diluted disinfectant;

— Don't use other people's towels;

— Wash your hands immediately after using embrocation; and never put on a crash hat with oily hands – the oil will run into your eyes with the sweat.

Finally, remember that whatever the event and however well or badly it went, you have an obligation to yourself and to the image of the sport. Bikies have notoriously loud voices and comments and disputes which sound modest to you, while your blood's running, sound offensive to everyone not involved. Don't argue or shout and bawl at the end of a race. Refuse to get into disputes. Never swear. Calm down, splash your face, and pull on a tracksuit; then, after asking for a second opinion on events from your coach or a team official – someone who wasn't racing – make your protest firmly and discreetly to the officials involved. You'll make all the more impact by putting up your case with dignity.

3 A bike for the job

A bloke I knew used to get through equipment faster than anyone in history. He made me want to buy a bike shop. He'd unbolted something and fixed on something else every time I saw him. If anything ever wore out, it would only have been through polishing. He was a bike worshipper.

Now, there's every reason to use the best equipment you can afford. It's very embarrassing to be the only bloke in the race with a Sturmey Archer gear (although actually there've been riders who've done pretty well with them, ticking their way through 100s and 24s). But equipment's not an end in its own right. A bike is just a gadget. Maintain it, keep it clean, take a pride in it. But remember that it doesn't do anything clever for you. It lets your legs turn circles and push rubber against the road, nothing more.

Sit on it correctly and pedal it properly and all that's left to worry about is your fitness. And, if you're determined to ride something really strange, remember the rules.

You can't just ride anything in a bike race (not those under UCI rules, anyway). So here for your interest are the restrictions:

- No longer than 2 m
- No wider than 70 cm
- Bottom bracket spindle within 24 and 30 cm off the ground
- Saddle nose no more than 1 m 12 cm higher than the bottom bracket spindle
- Bottom bracket spindle and front axle within 58 and 75 cm
- Bottom bracket spindle no further than 55 cm from the rear axle
- Propulsion only by the leg muscles
- No device to lessen air resistance.

Position

Think about it a bit and you'll realise that you're just a puppet with all the strings on the inside. You have limbs and joints, like a puppet, and you have control strings to move them. They're your muscles.

Every joint has two sets of muscles. The hamstrings flex your knee and the quadriceps straighten or extend it. The quadriceps are the big bulky ones in front – the ones you always wished you'd tightened when you had your picture taken – and the hamstrings are the ones at the back that hurt if you run without stretching them first.

As you pedal, the two groups take turns, first bending the leg, then straightening it. As one group comes into use, the other one relaxes. The

Getting the saddle height right means having more push than you thought. Note the greater than usual difference in saddle and handlebar height, because of the size of the rider (Phil Edwards).

one contracting is called the protagonist (or prime mover) and the other is the antagonist. The balance between tightening and relaxing makes the movement smooth and controlled.

Muscles, like those in your back or stomach which just stay taut to provide a base for the others, are called synergists. So much for the technical terms.

Now, it happens that protagonists work better when the joint's not too bent. That's why bunny-hops are so difficult and, incidentally, dangerous. Your leg muscles are strongest when they're nearly straight. If your saddle's too low, it'll stop your leg straightening and you'll lose power.

A good many years ago, researchers at Loughborough reckoned that the perfect saddle height, from pedal to saddle top, was 109 per cent of your inside leg length. The news brought them hoots of derision, but they stood their ground. They also said that an error of just 4 per cent made a considerable difference. That was in the mid-sixties, and since then – even in countries which have never heard of Loughborough – saddles have got higher season by season.

Much more recently, the team manager and former French professional, Cyrille Guimard, took fifteen of his riders to the wind tunnel at the Renault car factory. He and a physiologist found that the old method of setting saddle height – raising it until you can barely pedal with your heels – put the saddle too low. It was inefficient for the muscles and less aerodynamic. Only a considerable hiking up of saddles right through the team would produce a benefit.

Greg LeMond's riding style changed so much that it terrified him. And he, remember, had been world junior champion and pursuit silver medallist. He'd done pretty well, in other words, with the bike as it was. And yet Guimard told him to raise his saddle an inch and a half (about 4 cm).

He also told him to raise it slowly. In fact LeMond was so shocked that, in a show of bravado, he raised it the whole inch and a half at once, just for a day. He felt he could hardly reach the pedals.

'Yet Guimard was right,' he recalls. 'Now the saddle height seems normal. Once I got used to it, I realised how much difference the right position makes. Not only did I ride better, but all the muscles in my body loosened up. I never had lower back pain any more, my arms were never sore. Most of all, I was using the muscular force delivered by my legs much more efficiently. This meant that my entire body was better rested at the end of a long race.'

Guimard checked rider after rider and re-checked his arithmetic. Just as the researchers at Loughborough found there was a common link, so Guimard found his own magic figure. Only, whereas 109 per cent is

reasonably memorable, Guimard had the ill grace to settle on 0·883.

He found that if he measured a rider's inside leg from crotch to floor, pressing the tape firmly but not violently into the soft flesh that would be squashed by the saddle, and multiplied it by 0·883, he got his ideal height.

The result, according to Guimard, is the correct distance between the dip in your saddle and the centre of your bottom bracket spindle. His rules say you have to use Campagnolo pedals, medium-thickness cycling shoes like Adidas, and 170 mm cranks.

You might like to compare both sets of figures. An inside leg of 33 inches (83·8 cm) would give you:

- By the Loughborough method:
 $33 \times 109 \div 100 = 35.97$
- By the Guimard method:
 $33 \times 0.883, + \text{crank length of } 6.75 = 35.889.$

And that, given the innaccuracy of expressing metric crank lengths in inches, means there's no worthwhile difference. My own feeling is that you can't have an exact figure for everybody simply because there are too many variables — not least the length of your feet relative to your legs and the angle at which you hold your feet as you pedal.

All the same, it's worth doing if you find the figures mean a move of more than half an inch. The Loughborough boffins reckoned just a 4 per cent error — in this case a saddle 1·4 inches (3·5 cm) too low, which is the amount LeMond had to raise *his* saddle — made a marked difference, so it's a safe bet that even half an inch (1·3 cm) would have an effect. Be warned, though, that like Greg LeMond you might find the ideal saddle height higher than you think. It's all a question of habit, and habits can be broken. Do it by raising your saddle by just an eighth of an inch (2 mm) a week. If you have trouble getting the pin out far enough, switch to one of the longer models made for mountain bikes.

There have also been tests on the shoeplate position. I think the days have gone when shoeplates were nailed in place. One dodgy nail early in the proceedings meant you were stuck with a wonky shoeplate. Your brain soon got used to it, but your knee never did. Every so often you wondered why it hurt. Metal shoeplates also wore away the alloy frames of pedals, kicking your foot over at a permanent tilt.

Take very great trouble over your shoeplates. Replace them frequently. And don't walk in your best shoes. The perfect position brings the ball of the foot directly over the pedal spindle. You get an illusion of strength by sliding your feet forward and of acceleration by moving them back — six-day riders often have their feet less into the pedals than you'd expect from a roadman — but there's much more illusion than fact.

Take the allen key with you on your first few rides in new shoes. Your mates will think you're a pain in the neck as you stop every few miles for another adjustment, but it'll pay off. You might in the end settle for tilting your ankles slightly in or out. But remember that extremes are *always* wrong and that the angle should be almost invisible.

There's been a trend ever since the First World War for frame angles to get steeper and steeper. They've moved at around a degree a decade for road bikes, with 75-degree seat angles being common in the 80s, 74 in the 70s, 73 in the 60s and so on back to the soft, relaxed frames that the old stars like Frank Southall rode so successfully.

Steep frames feel livelier and bumpier. But you can only move the seat tube more upright if you make the cranks longer – which is impracticable because they'll bang on the wheel – or move the saddle back, which has its limits. After all, the back of your kneecap should always be vertically above the pedal spindle at its furthest forward. Steepening the seat angle is just moving you further forward along the bike.

It's essential to have your shoeplates correctly adjusted . . .

It's a fashion to beware of for this reason. You can always tell when you're riding a steeper head angle but rarely a steeper seat angle. So, the taller you are, the more important it is for the seat tube to be shallower. Otherwise your long thighs will bring your knees forward of the pedals. Continental professionals have got this balance rather more than their British cousins. It's easier for them, because they talk not about frame angles but seat tube length and how far the seat cluster is behind the bottom bracket. Therefore thigh length comes into their reckoning.

I think probably the ultra-steep frame craze has peaked and we're about to see things going the other way. Gerrie Knetemann had, and Greg LeMond and others all now have shallow seat tubes to put their positioning right. Knetemann's, say the people who built it, was 71·8 degrees. Beryl Burton's is 72. Their head angles might be steep (Burton's is actually 72 parallel) but the seat tubes have an almost tourist-like gentleness. Don't let fashion push you the wrong way.

Extremes of 75 can work on the track, where the surface is smooth and races short, but a 74 head angle is wiser for criteriums and cyclo-cross, 73–74 degrees is better for medium-height roadmen, and 72–73 for stage races. They're maximum figures.

By the way, if your saddle *has* to be wrong, it should be slightly too far back rather than too far forward. You can always slide on to the nose when the going gets harder and your too-far-back style will give you more back power on the hills. In fact you'll instinctively slide back as you climb; it's to let your ankles flex slightly more to overcome the weakness of pedalling when your cranks are vertical, and to make more use of your backside, your lower back and your straighter arms. There's no room for

correction if the saddles's too far forward; you'll waste power and strain an already tested joint – your knee.

Oh yes, and remember that you'll have to change the fore-and-aft adjustment of your saddle whenever you change its height; the seat tube slopes, so any change will bring the saddle further forward or back.

Mr Plod, the policeman who gave me road safety lessons, insisted that the only way to measure saddle height was from the ground. If you couldn't get your feet firmly on the ground, the saddle was too high. That's absolute nonsense for a racing bike, of course, as everyone except dear old Mr Plod realises. Getting your feet on the ground has as much connection with bottom bracket as saddle height.

There are trade-offs in bracket height. The higher it is, the faster you can corner without clipping the ground – an important consideration in criterium racing. You can pick up a length on every corner if you can pedal where others have to freewheel. On the other hand, your centre of gravity's higher so your pedalling ability is partly a compromise for not being able to lean as far.

Again, a higher bottom bracket would let you use longer cranks, but the very events in which long cranks are most useful – time trials – are the ones in which a high bottom bracket has least value. You're not cornering tightly.

Steep tracks favour shorter cranks rather than higher bottom brackets (a balancing problem again) – although rather a high bottom bracket than a low one – and shorter cranks are better for acceleration anyway.

The one time that a high bottom bracket comes into its own is in cyclo-cross racing. Anything that lessens obstructions is a good thing and the centre-of-gravity problem gets hidden in the slower speed and the endless other problems.

As a general rule, 28 cm is fine for cyclo-cross, 27·5 cm for track sprinting, 26·5–27 cm for road racing and pursuit, again depending on crank length. Sprinters prefer 165 mm cranks, pursuiters and cyclo-cross riders 170 mm, roadmen and time trialists 170–172·5 mm, and tall and experienced time trialists even 175 mm.

The one remaining calculation – handlebar height – depends on three things:

– The distance you race
– The need for acceleration
– Your height.

The bars should always be lower than your saddle. That much is common knowledge. In frames of up to 22½ inches, the difference in height might be just an inch or two (2·5–5 cm). The difference then

becomes markedly more as frame height increases, because reach increases disproportionately with height. The longer your reach compared to your height, the longer your stem (to carry you forward) and the lower the bars (to keep the weight on the front wheel and let the curve in the forks keep your bike in a straight line – the caster action).

But *how* deep and *how* far depend on your race. The standard position is for your elbows to be about an inch ahead of your knees when you're crouched in a comfortable, streamlined position, holding the inside of the bends.

That's for road riders and pursuiters. But sprinters and kilometre riders are racing for only seconds. They can sacrifice comfort and diaphragm space, and benefit from the extra streamlining of lower bars and the greater power of a slightly shorter reach. Interestingly, the conflict only rarely arises because, although cyclists as a whole can vary from really quite short to rather more than 6 feet (1·83 m), good sprinters and kilometre riders are very often only average height or slightly less. That's a generalisation, naturally, but it tends to be true because taller riders rarely have the muscle bulk that explosive riding needs.

Wheels

We live in a happy age. Time was when tubs were expensive – so expensive that old-timers carried their sprints on carriers on either side of the front wheel, rather than ride them to the start of an event. They also fitted 700 mm wheels, whereas the British standard was 27 inches, which meant that every wheel change forced you to realign the brake blocks.

Now, high-pressures are truly that: 90 or even 100 psi. Close your eyes and it's hard to tell whether you're riding light pressures or heavy tubs, and the safety from punctures means some folk have switched to pressures for early-season road races on gritty roads. One British professional team advertised that they used them off-season. As a result, you can safely train on them as well. You can also standardise on sprint-sized 700 mm wheels, which is great.

Tubs are never cheap, but they've never been less expensive, if you see what I mean. Their price didn't change for years in the midst of great inflation. The victims were the firms that couldn't cut costs to compete and they disappeared, leaving fewer firms on the market than there have been for years.

Tubulars are either cotton or silk. Silk is better for lighter tyres – say 140 gm and less – because it opens into a better shape. On the other hand, the fabric rots more quickly in the wet British climate and when a silk tyre

punctures it goes with a bang. As a result, mechanics often switch Tour riders to cotton tyres for mountain descents, to lessen the chance of a blow-out at speed.

There are optimum pressures for tubular tyres but, since the makers don't tell you what they are, you have to work them out for yourself. Use a stirrup-type track pump, by the way, because you'll give yourself a coughing fit using a conventional pump. The pressure depends on:

— The size of the tyre
— The condition of the road
— Your weight.

So, the narrower the tyre, the greater the pressure it needs. A 19 mm section track silk might take 150 psi; a heavier, 23 mm section job might need 130 psi. That's on the track, where rolling resistance can be least and surfaces best. On the road you need heavier tyres, with a lined centre and fish-bone edging, and lower pressure – in this case between 90 and 105 for the front and 105 and 120 for the back, depending on the lightness of the tyre.

I suppose you could, if you wished, make a costly experiment to see how much air you can get into a tyre before it burst. It would probably surprise you. But actually there's no point in over-inflating. Rolling resistance doesn't lessen proportionately with each extra pound, but jolting from the road surface certainly does. What you gain in easier rolling in a long road race or time trial, you'll lose in fatigue from the extra vibration.

By the time you come to the extra width, tread and rough going of cyclo-cross, tyre pressures are down to just 80 psi.

By the way, I don't suppose we'll get accustomed to using the Continental system of atmospheres when measuring air pressure. So, in case you've bought a pump measured their way rather than ours, here's the conversion:

atmospheres											
0	1	2	3	4	5	6	7	8	9	10	11
0	14	29	43	58	73	87	101	115	130	145	160
psi											

Try not to use either new or old tyres. So far as I know, factories no longer keep tyres in their stores until the rubber has matured. Nor can wholesalers afford to keep them for several months before they send them

out to the shops. The result is that you have to do it, somewhere dark, dry and not too cold. For up to around nine months after it was made, a tyre will be soft enough to pick up small stones and sharp bits and pieces along the road. It then goes down. Keep it for several years, though, even without riding it, and the rubber will get too hard and dry and you'll skid on wet corners.

It's a good idea to go training on a new tyre before you race on it. It'll wear off the shiny surface and it'll show you whether it's faulty.

Standard spoking is 36 front and rear; it would be silly to use anything lighter if you've got just the one pair of race wheels. Once you've got a choice, though, you might like to experiment with a pair of 28s – provided you want them for time trialling, track pursuiting or long-distance road races. The significance of the distance is that violent attacks, which stress wheels a great deal, decrease as the distance increases. The danger, of course, is that one broken spoke puts you out of the race, whereas the buckle in a 36 might still clear the brake blocks.

Tom Simpson, who was a lightweight without a violent jump, rode 28s in the Tour de France more than 20 years ago, so it's worth a try if you're not too heavy. Similarly, they're also worth a go in time trialling – but only once you've got a respectable personal best. You'll just look plain daft if you turn up on 28s when your best for a '25' is a one-four.

There are two gauges of spokes – 15/17, which is 0·072 in (0·183 cm) at the thick end; and 14/16, which is 0·080 in (0·203 cm). Campagnolo and most other classy hubs are drilled for the thicker 14/16 gauge. Thinner spokes will give you a softer ride as the spokes move in the flange. You may actually want this, but there are two risks: the first is that the spokes will break more frequently; the second is that the movement will widen the flange drillings, so that even 14/16 spokes will be loose.

You can control the rigidity of wheels in other ways. Extra-rigid isn't always best, by the way. It can mean extra-bumpy and extra-tiring, too. Fashions play a role, but the trend over the years has been from large to small flange on the road, but to stick with large flange on the track. The commonest road spoking is 14/16, 36 spokes to each wheel on small flanges, with each spoke crossed three times.

The significance of the crossing isn't precisely the number of times one spoke touches another; it's simply an indication, simply expressed, of the length of each spoke. Longer spokes have more twang and give a softer ride. This particular combination gives a wheel which copes well with sprinting and climbing but flexes enough on bad surfaces.

At the other extreme, spokes can be tied where they cross and then soldered (popular on the track, but useless unless the solder alloys with the spoke; if it doesn't, you've just got a blob of solder with the spoke sliding

up and down inside it) and they can even run radially from hub to rim. More than one prominent rider has ridden wheels with spokes crossed on one side and radial on the other.

Mike Mullett, a man who knows a thing or two about frame and wheel technology, expressed things like this. The higher the number, the more rigid the wheel.

Spoke crossings		Hubs		Tied and soldered	
× 4	1	Small	1	Not T/s	1
× 3	2	Large	2	T/s	2
× 2	3				
Radial	4				

You can, therefore, get the same rigidity from different combinations:

Example 1:		Example 2:	
Large-flange hub	2	Large-flange hub	2
× 2	3	× 3	2
Not Tied and soldered	1	Tied and soldered	2
Total	6	**Total**	6

A word now about freewheel blocks. You'll understand, I'm sure, that because the block is screwed to the side of the hub, it widens the wheel. The flanges, on the other hand, stay where they were. So you have a left flange at the outside edge of the wheel and a right flange that's by no means at the edge. Build the rim where a wheelwright would put it — equidistant between the flanges — and the tyre will jam on the chainstays. Dish it to bring it midway between the left flange and the outside sprocket and you've got a wheel inherently weakened by having distorted it.

The distortion of a 5-speed block is well within the capacity of the spokes (some time-trialists save weight by using just 4 and sometimes only 3 sprockets, but the base is usually a 5-speed block). A 6 or 7-speed, though, is not, and spokes start breaking.

You can't ride a wider block with consistent success unless your frame is built for it. The frame builder has to place the wheel-ends 125 mm apart instead of 120 mm. The dishing is then half the extra width — namely 2·5 mm — which causes a strain but not a dangerous one. The old trick of mounting a 6-speed block on a 5-speed spindle means fitting a narrower locknut on one side and spacing out the spindle with a 5 mm washer. The

dishing needed is now twice as much as for the 6-speed rear end, and the strain on the spokes becomes excessive.

There's little inherently risky with a 6-speed block (or even a 7-speed, which are made to the same width), but there will be if you mount it on the wrong spindle.

There are no gears at all on the track, of course – just a single fixed sprocket. The pressure of pedalling keeps the sprocket fully screwed in place. Despite frequent calls for a change, the rules still insist on a lockring. The theory is solid enough. It says that the only brake you've got is backward pressure, and that blokes with big legs have been known to wind the sprocket right off and get the chain tangled up in the wheel, resulting in a big crash. The fact that most riders don't get anywhere near that strength is by the by; the risk still exists.

The no-lockring lobby, on the other hand, looks at practice rather than theory. It says that a rider who clips his pedal on the banking will, with luck, have the strain taken by partial unwinding of the sprocket. He'll steady himself and carry on pedalling before the sprocket comes right off. Clip the banking with a lockring, on the other hand, and there's nothing to give. The crank will carry on turning and will lift the bike into the air, taking the tyre off the track and sending bike and rider whooshing down the banking, possibly demolishing other riders lower down.

Either way, the rule says fit a lockring.

Gearing

Experienced trackies take several chainrings to a meeting, because a 1-tooth change to a chainring is the smallest you can make to a ratio. It's also a good deal simpler than changing a sprocket. More on gearing in Chapter 6.

The trend on the road has long been from narrowly-spaced front chainrings and wide blocks to wide chainrings and narrow blocks. In a fairly flat race, you might choose 48 to 52-tooth chainrings with 14–15–16–17–18 (this is unrestricted gears, of course). You'll need wider gears for the hills: say 53/42 with the same block, or even a 14–15–16–18–20–22, which is an old-fashioned but very effective range. The next higher range on the same basis would be 13–14–15–17–19–21.

Time trialists use higher and fewer gears. Many have just one chainring. There's no doubt that a larger chainring rolls better – pursuiters find the same – but accelerates more slowly than a small one, and that's the combination that's most popular. Physiologists have often argued that cyclists pedal too fast (coaches, on the other hand, say they pedal too

slowly). The difference comes because the boffins are looking solely at output, whereas coaches are looking at things like tactics, attacks and youthful development. It's altogether another subject but, while the fastest times have usually been set on higher-than-usual gears, it's one one-way alley which commits you to being a time trialist for the rest of your career. For the full argument, see this book's companion volume: *Cycle Racing – Training To Win*.

Finally, gearing for cyclo-cross depends almost entirely on the course. I'll have more to say about that in the chapter on 'cross.

4 In control

The greatest fun in the world is riding down a long hill with a load of fast bends. Boy, you can whoop through the swerves like Franz Klammer. It's great. It's also quite a complicated mental feat. Your brain's thundering away making constantly-changing adjustments. How much weight do you need to balance the centrifugal force? Where does the bike have to come upright and bank the other way for the next corner? What's in your memory about previous hills, about the grip of different road surfaces, of wet and dry, and so on?

The mechanics are quite different from driving. You steer a car first and then it leans outwards on a corner. On a bike you lean the bike inwards and make no conscious attempt to turn the corner. If you do, it all goes wrong. What actually happens is that you lean out across the bike's point of balance. Your weight makes the bike tilt and you turn the front wheel in the direction of the tilt to form a prop.

By this stage you've effectively made a triangle. One side is the tangent of the curve (or, put simply, the direction you'd travel if you suddenly straightened the steering). The second side is the direction in which the front wheel is pointing. And the third side is a direct line between your centre of gravity and the tip of your front wheel. You'll stay upright provided you don't let the angles burst apart.

The simplest way of breaking the triangle is to move your body weight in a slightly different direction. And that'll happen if you look *outside* the bend. So, to take a corner in the tightest and fastest possible way:

— Look down at a point a yard ahead and inside your front wheel
— Straighten the leg on the outside of the bike and place most of your weight on it
— Shift your weight on to the outside arm and lower your centre of gravity by holding the bottom of the bars

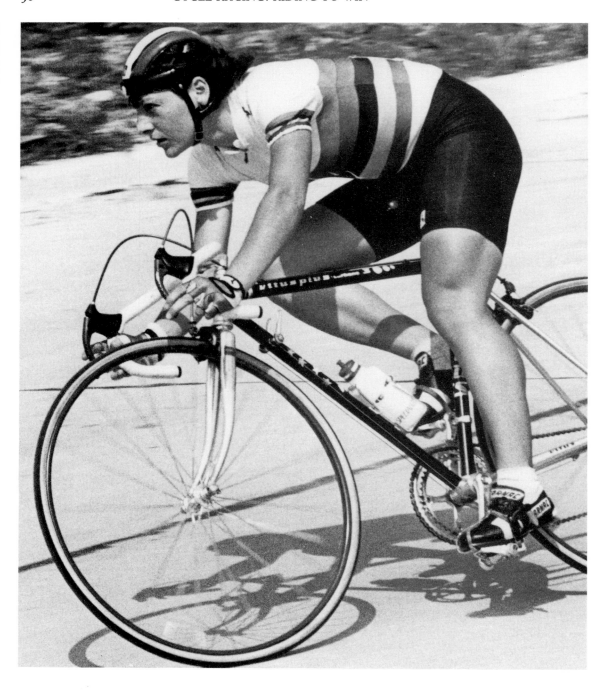

— Point your bent knee towards your route out of the corner, but don't exaggerate the movement.

Do these four things and your weight will shift into the corner and your momentum will be angled at the route you take out of the corner. Anything else makes you soar excitingly across the road, to the interest of anyone alongside you.

The other big difference from driving is the approach to the corner. Driving instructors encourage you to drive parallel to the kerb. Bikies, on the other hand, move out from the corner on the approach, start the turn with a few feet to go and then cut the corner. The aim is to spread the turn along the road, so that the banking's reduced and you can keep pedalling for longer. As you approach the corner, change into the gear you want for the other side. Sit a little further back on the saddle, don't use your brakes once you're into the turn, and start turning your pedals to bring the bike upright when you're halfway through the bend. As you push down with your inside leg, the one that's raised, use your inside arm to pull up on the bars. As your outside leg passes the top centre of its revolution, put all your weight on it, pull up with both arms, and you're away, sprinting out of the corner.

Use your brakes as little as possible and keep pedalling for as long as possible. After all, every second without pedalling is a second of deceleration. In a criterium, where corners come frequently, you'll have better control and greater responsiveness if you pedal and brake at the same time.

It sounds complicated, but then I did say your brain was working like a computer. Most people get it just about right, but conscious practice will make you perfect. It's a great help to see just how you can bank the bike without the pedal clipping as you pedal and also how much further you can bank the bike before your tyres break away.

This last isn't a comfortable experience, of course, and it takes a lot of nerve to keep pushing things to their limit. Fortunately, bike tyres are made of a special rubber which is remarkably sticky when it's stressed sideways, and it sticks on the road like an india rubber sticks when you try to push it across a table top. You do have to make sure they're securely stuck to the rim, though.

Great criterium riders are modern-day kamikaze pilots. The difference is that they don't crash.

But beware loose gravel, wet roads and, worst of all, wet mud. It's never worth risking very much on wet roads because a fall will take you and probably quite a few others out of the race, generally painfully. For that reason, don't overlap a back wheel to the outside. If he falls, centrifugal force will take him on to your wheel and you'll go down as well.

(Opposite) *Brake before the corner, put your weight on your outside leg, push out your inside leg, and belt round it.*

You can gain a lot on corners if you learn to corner tightly. Go through every corner at full speed – the geometry of a racing bike makes it more stable the faster you go. A road race bunch swings out, which leaves a clear run of up to 50 yards (38 m) on the inside. A racing bike is 66 inches (about 168 cm) long so with a bit of nerve and nifty sprinting, you should be able to make up a couple of lengths each time – very useful in a kermesse.

Don't push it too far, though. And don't go ahead if everyone moves back in on the corner itself, or you'll end up being pushed up against the kerb by someone else's back wheel. If you need to, shout a general warning. Don't shout something specific, like 'inside' or anybody with half an ounce of sense will move across to block you. A vague but urgent 'whup' sound will do. It's like being in your car when another driver hoots urgently behind you. Your first reaction is to cancel whatever you were doing and keep to a predictable line. You sense danger and you stay to the most predictable and safest course. That's the way the bloke ahead thinks when you 'whup'. And he'll let you through.

It's worth having this frame of mind even where you think you'd need it least – in a time trial. Snappy cornering saves time whenever and wherever it happens, so think yourself through it every time. If it gains places in a criterium, it'll save seconds against the clock.

When, as you surely will, you fall off, you'll see everything happening in horribly slow motion. It's all over in a flash for everyone watching, but your brain's working so fast that you can make snap decisions. There are two things to do. The first is to hang on to your handlebars. That keeps you in a tight crouch and it means your shoulders are protecting your head from the initial impact (people who went about banging their heads have died out along the years, so there's an automatic reaction as you fall to protect your head). Then let go of the bars once you're well on your way to hitting the road. That same instinct will force you to shroud your head even further.

In the States, the rules now insist you wear a full pudding-basin helmet. European rules call only for what Americans dismissively call a leather hairnet. The first looks better but in fact doesn't do a great deal for direct impact and isn't made for accidents involving cars and brick walls. The leather helmets could be more functional and less stylish than they are, but their critics overlook the fact that they're *supposed* to tear to bits or even snap on impact. That's how they absorb the blow; if they didn't give, there'd be little difference between whacking your head on the helmet and bashing your head on the road.

The greatest immediate risk isn't to your head but your hands. I doubt you'd ever need to wear mitts in a time-trial and maybe not in a cyclo-

cross, but they're essential in road and track races. You can cut a knee or an elbow and carry on riding. But a deep graze on the heel and palm of your hand will keep you off your bike for days. Mitts also give you a better grip on the bars.

By the way, have you ever realised that you're much more likely to fall to the left, even on a straight road, than to the right? Don't ask me why. Just look at your mates and see which side they have most of their scars. The only people who fall the other way are trackies, but that's only because they ride anti-clockwise round the bankings and lose their grip. I don't know what you can do with this information — wear something protective on your left elbow, perhaps — but it's true. It can't even be the extra weight of your heart, because that's only just slightly left of centre and balanced by the heavier equipment on the right of your bike. You could make yourself very famous by finding the answer.

Bad roads sometimes make you wish you could have an accident, just so that you could stop riding. There were stretches of cobbles near my home in Belgium that went on just half a mile, but they cut my speed by half and felt like ten times the distance. We don't have roads like that, but we do have something almost as bad. We have roads so frequently dug and poorly repaired that they might as well be cobbled. At least with cobbles the jarring is consistent; British roads these days give you big wallops at two-second intervals rather than several minor wallops every second.

Sit back further on the saddle and hold the tops of the bars with your elbows well bent. The shocks then run through the fork rake and make your hands and forearms tingle, and your backside stops the back wheel bouncing around. It's never comfortable, but it's miles better than a normal position. You might also find that a higher gear and a slightly knees-out style help. Keep telling yourself to relax; it's almost impossible, but keep telling yourself.

There's only one way to cope with cobbles and other bad roads — copy Greg LeMond by holding the tops, bending your arms, and let the bike take the bounce.

5 On the road

There are different groups in a road race. There are the stars and the mini-stars. There are those who look pretty fit and might be dangerous. And there are always a few who talk too much and keep laughing. They're the ones who get shot off in the opening laps or bring everybody down in the sprint.

Actually, the old national coach, Norman Sheil, had a better way of looking at it. He reckoned you could divide the field into four: there'd be those who had trained hard and reasonably expected to win; there were those who were pretty fit and pretty good and could win with a bit of luck; there'd be those who stood no chance at all and rode round to make up the numbers; and there'd be the laughers and shouters, who secretly didn't mind if they got dropped early on because they could settle down and get to the finish at their own pace.

This last lot are a real nuisance to the officials. If there were only one or two, they could see the main finishers over the line and leave the stragglers to it. Instead, the plodders get further and further behind and either worry the commissaire, because he's afraid they'll get lapped, or infuriate the judges because they've got to hang around in the cold waiting for them.

The real problem for you is that half the field are a potential danger. Ride too far back and the no-hopers can take you off the back at the first real opportunity. They're also quite keen on touching wheels just ahead of you and felling all those who follow.

The first rule of road racing, therefore, is to be as far up the bunch as you can. This has several benefits:

- The scrubbers don't knock you off or hold you up;
- You've got a good view of what's going on and any attacks that your main rivals might launch;

— You can get round corners much more effortlessly (everybody at the front will sprint out of a corner, knowing the whiplash will make cornering pretty miserable for those who follow);
— There's more safety room in which to slide back through the bunch if you're a rotten climber.

Now, you come up against an interesting mathematical relationship here, and it's at the heart of road racing. It says that at 10 mph (16 kmh) on a flat road, about half the effort of cycling is put into overcoming rolling resistance and the other half into overcoming wind resistance. On the other hand, at 30 mph (48 kmh), it changes to just 10 per cent for rolling resistance and 90 per cent mostly for shifting the air aside. If you're interested in the arithmetic, it's because the power you need to overcome rolling resistance rises in proportion to the speed, whereas what you need to overcome wind resistance is proportional to the *cube* of the speed.

Hol Crane, from the remarkable family Crane (Nick and Dick rode up and down Mount Kilimanjaro and deep into central China), puts the ratio like this:

MPH	6	10	15	20	22	24	26	28	30	32
Rolling resistance	6	10	15	20	22	24	26	28	30	32
Wind resistance	2	9	31	74	99	128	163	203	250	303

(International Cycling Guide, 1980)

You can translate this into something more practical: that the faster you ride, the more you gain from being behind something else. Folk worked that out as long ago as the 1890s, when paced racing began – something which had been impossible on the old penny-farthings because of the size of the front wheels. It came because riders started tucking in behind each other and the craftier ones began loafing until the finishing sprint. When the organisers compromised by introducing formal pacers who took no part in the race, they found one man was too little and they worked progressively from individuals to tandems and even four-man tandems, and on to 1,000 cc motorbikes, so great was the advantage to the following riders.

Mile-a-Minute Murphy claimed he could follow anything if he were sheltered from the wind, and the world laughed. But he clocked his 60 mph as long ago as 1898, behind a railway train. You can see the shelter you get from something as small even as another racing cyclist from team pursuit times: about twenty seconds less than those for individual pursuits.

Now, the further up the bunch you ride, the less the protection you'll get. It's a trade-off for the smoother, safer and tactically more aware ride you'll get without a mass of erratic rivals in front of you. When a bunch is unprovoked, the pace drops because nobody has an advantage but anyone could put himself at a disadvantage. Eddy Merckx may have been able to string out a whole bunch, but mere mortals can't go tanking along at the front without blowing up horribly.

As the pace drops – perhaps just a mile to two an hour – so the advantages of an attack increase. We'll get to methods of attacking in a moment, but think now about what happens when somebody has a go. One of two things will happen: either he'll get away alone, or others will eventually or immediately join him.

If he's alone, it takes a lot of determination and strength, plus some tactical blundering by the bunch, to stay clear. If he's in a group, it stands a good chance of riding faster than the bunch (in fact, an attacking group has to ride faster only very briefly; once the gap's opened it's only got to match the speed of the chasers). The attacking group goes faster because it's reached a good trade-off between the flexibility and faster reactions of a smaller group, and the extra wind resistance that each individual rider has to overcome.

Bit-and-bit

A small group can get into a wind-cheating formation more quickly than a bunch. There's a common ambition – to get clear – whereas the bunch is confused. Some at the back of the bunch mightn't even realise that some have got clear. And it's easier to organise a small group into pace-sharing.

In Britain we call it bit-and-bit. In the States they talk about a paceline, which is rather prettier. Between the two you get an idea how it works.

Since wind resistance and shelter increase with speed, the paceline organises itself so that each rider is exposed for only a few seconds. Get your front wheel six to nine inches behind the rear wheel ahead, with your tyre slightly to the side of his. Resist using your brakes, and keep the pressure on your pedals as smooth as you can. You'll cause havoc behind you if you don't.

Get into a long line and build up the speed. At intervals, the bloke on the front swings to one side, eases and waits for the line to pass him. He then slips in behind the last man.

The more there are in the line, the shorter the time you spend at the front and the more energy you can put into 'pulling'. You can do bit-and-bit perfectly well with just two riders, but you may have to ride 200–300 yards apiece. Seven or eight riders can form a loop, with riders thrashing

A perfect paceline in operation, the nearside line going up, the far side going back. Note how close the wheels are.

straight through and swinging aside immediately. The next man swings over immediately he's clear and eases slightly so that he gives you protection behind his back wheel. And so it goes on. As the back man passes you in the line beside you, you just swing across and make your way to the front again.

You can get to remarkable speeds. The commonest fault is to accelerate as you reach the front (if you do, you not only break the rhythm, but the bloke at the back, feeling stuffed, finds he's got to sprint after the line he's supposed to be joining). It's no bad idea, either, to avoid changing gear or getting out of the saddle.

Don't change gear at the front unless you're forced to. Change down as you swing across and back up again as you rejoin the upline. Ride in a gear slightly lower than the most you can manage; it'll be just right then when you get to the front.

If you have to get out of the saddle, lift your weight on the leg that's pushing down the pedal. You may accelerate slightly but at least you won't stall very briefly as you take the weight on *both* legs and reduce the pressure on the downward pedal. You'll scarcely notice that you've slowed down, but to everyone else it'll seem the world has come to a stop.

Finally, don't stare at the back wheel ahead of you. It mesmerises you and it stops you seeing what's happening. Experienced riders will take a

line that avoids bricks in the road, manhole covers and the back of parked cars. But it can't be done all the time. Keep your eyes on the move; watch the back of the guy two riders ahead, move your eyes back to the wheel immediately ahead, and then back up the line again.

Really good riders don't watch the back wheel at all. Watch a bunch of Continental professionals at work and you'll see they know instinctively how far back they are; they keep their eyes on the blokes ahead, ready for every move.

Bit-and-bit fails in Britain once you've got more than ten or eleven in the group. You're then talking about a small bunch which could split again. They seem to manage it on the Continent, but even then there's no guaranteed success.

Echelons

Conventionally, British riders swing to the right when they change. It comes from riding on the left. Into a direct headwind, it doesn't really matter which, but when the wind comes from an angle, it makes sense to swing into the sheltered side. So, with a wind from the left, swing to the right; from the right, swing to the left.

Instinct governs a lot, though, and you may have to shout at everyone to get them organised. It's actually easier to swing to the right and let the faster line come up on the inside. It's because there's a temptation, when the fast line's on the right, to get nearer and nearer to the kerb and leave no room for the slow line. But there's no reason why it shouldn't be done and every reason why it should.

By the time the wind is coming from more than 30 degrees, the solution is to tilt the paceline. Britons and Americans call them echelons, which is a French word. So they're surprised to find the French themselves call them *bordures*. The Dutch and Flemish call them *waaiers*, which means fans, and that's the best word of all. The riders are fanned across the road.

The scope of forming an echelon in Britain is limited because the roads are winding and they're open to other traffic. A motorist bearing down on eight cyclists strung across the road has much the same feelings as the cyclists – a vision of impending doom.

For that reason, echelons are difficult to practise and to establish. Yet they're much more effective as a paceline in a cross or three-quarter wind.

If the wind is from the left, the left-hand rider rides firmly against the left kerb. The second rides alongside him but half a length back, the third half a length back on him, and so on across the road (or as much of the road as you can). It's the other way round if the wind's from the right.

The leading rider obviously can't swing across because he's bound on

one side by the kerb or the white line and on the other by a chain of riders. So he eases, waits for the second man to draw ahead, and then moves diagonally along the back wheels until he reaches the far edge of the line. The group by that time will have inched across to take up his space and there should be room to accelerate slightly and rejoin the line.

The emphasis is on the word *should*. What's more likely to happen is that everyone else who fancies getting into the game barges in as soon as there's the slightest gap. If everyone played like good sports, all would be well. In fact, you may well find you have to push into the front line ahead of your turn. This, of course, greatly upsets the people in the front line and, more specifically, the bloke currently over by the kerb. Suddenly he's got less room.

Still, with luck, the formation will be decided in a couple of rotations and you can settle down. If someone does then push into the back row, you can use your elbows and your weight to keep him out. But don't bring everyone down in the process.

If you want to reduce the number in the echelon, perhaps to squeeze out a handful of rivals, just start using less of the road. Instead of stretching

A set-up job, but a pretty good illustration of an echelon, with the wind from the riders' left. Keith Lambert (leading) now eases, Paul Carbutt (2nd) takes his place and everybody swings over.

from kerb to kerb or kerb to centre, use just half the available space. Pronto, half the echelon's forced – with much swearing – to tail out behind. Practised Continental teams can group four or five mates together and squeeze the line so hard that they're operating almost a private echelon of their own.

The angle of the echelon depends on the wind, but it should never be anything less than diagonal, even in a 90-degree crosswind. That's because you have to trade off the side wind with the air directly ahead of you.

Apart from the angle and the slight acceleration to get back into place, an echelon works in the same way as a good paceline. You should be getting one line of riders moving to the right, another to the left, in a chain. It takes a lot of skill but the benefits are colossal. It's simple to get a conventional paceline going, but an echelon is much harder. If you can get one running properly, the best riders will be in it (because only the more skilful riders have learned how to do it and recognise the right time) and the rest will end up as a long dribble of riders on each others' wheels.

The first of those riders will, if he's got any savvy, try to barge his way into the echelon. He'll get no shelter until he does. The tighter you keep your group – shoulder to shoulder – the harder it is for anyone else to join in. And before long they'll be dropped.

Even Continental professionals, much more used to echelons than we are, don't find it easy to form one, and even harder to get in the front one. Don't hesitate to shout and push if you want to get a line started. And *always* try to get a second line under way if you've missed the first. Then you can jump across if you feel strong enough and try your luck at muscling in. It takes a lot of nerve and a fair bit of bulk and strength, but do try – provided you don't bring everybody crashing down in the process.

We can't all be burly Russians and Czechs, so if you don't manage it, remember that you'll always be guaranteed a space back in the second echelon because you're effectively reversing into it. They can only keep you out by slowing down.

Bridging a gap

This leads me to another point: the way to bridge a gap or even to get clear. The usual way to attack (apart from keeping the pressure piled on, on a hill, which we'll come to) is by sudden acceleration to open a gap and remove wind protection from your chasers. The usual British reaction, especially among less experienced riders, is to chase immediately. A rider

goes and the rest charge after him until they catch him, whereupon they all slow down again and nobody is any better off.

It was noticeable when I lived on the Continent how different the approach was there. A rider would be allowed 60 to 70 yards clear. Instead of the bunch trying to reabsorb him, it would keep its distance and individual riders would take turns to jump the gap. 100 yards is about the most you can close with a lone, all-out effort, and often it would be successful. The second rider would reach the break, sit there for a while until he recovered, and then the two would work together. Two or three others would join them and a good break would form.

The cheekiest example I've seen was in a two-day race in Essex where the Kirkby club from Liverpool, at that time the strongest in the country, had two of its three riders in the breakaway. We realised there was something going on when their manager, Ken Matthews, told the break to slow down. The bunch accelerated at the news that the fugitives were apparently tiring (they didn't know about Matthews' instructions, of course) and the two groups closed to about 100 yards. The chasers were licking their lips when the third Kirkby rider burst away, crossed the gap, completed the breakaway and all three moved into the distance.

Teach yourself never to make a move unless you yourself benefit. That doesn't mean loafing in a paceline or simpering along at the back of the bunch waiting for the sprint. What I mean is that you should concentrate on *positive* tactics and not on spoiling efforts. Stopping somebody else winning isn't a way to win for yourself. But to co-operate with someone else increases both your chances.

Attacking

Time trialists gleefully point out that good time trials are often faster than good road races. Nothing delights a time trialist more than one of their brigade winning, alone, against the more raucous and gaudy roadmen. Obviously it happens, because time trialists have a very special skill. But there's more to it than that, even letting aside the hills and tricky corners of a road race course.

Road races have lower average speeds, but the peaks are higher. The speed doesn't matter, just the order in which riders cross the line. Riders who get clear have to ride faster than the others for only a moment; after that they only have to match the speed of the chasers.

The difference in speed comes in the attack. An attack is a way of opening a gap between you and somebody else, so that neither of you has the benefit of shelter. It succeeds in one of two ways: because you use surprise in the suddenness of your acceleration; or because you can

overpower your rivals by riding away from them. Indeed, if you're feeling super-strong, you can just keep barging clear at the front until in the end everyone gets fed up and lets you go. It's chancy, of course, but it has worked.

For lesser, more ordinary folk, good places to attack are:

— On corners, because the first riders can get round much faster than the rest;
— In the last quarter of a hill, when everybody else is feeling shattered;
— When an earlier attack has just been caught, because everyone eases up;
— At the top of a hill where it eases into a drag, because you can get into a higher gear quicker than those who are still coming up the main climb;
— When it starts raining, because everybody feels cheesed off and because the blokes at the back are getting soaked by spray and suspect their brakes might not be working as well as they'd hoped;
— Immediately after a *prime* (an intermediate prize offered at the end of a lap or at the top of a hill or outside somebody's pub when they're looking for a little publicity) because everybody eases up for a breather.

Gift circuits for attacks have winding roads with high hedges because a break has a much better chance when the chasers can't see it. Extremely bad places are into a headwind, with a huge tailwind, downhill on a straight road, and almost anywhere on a bleak airfield.

The sudden acceleration is called a jump. You just get out of the saddle and belt up the road as fast and as far as you can. What happens next depends on the lethargy of your rivals (the larger the group, the greater the lethargy), the distance still to go, the weather, your own reputation, and the point at which you attacked.

The further you are from the finish, the better it is to take up to ten riders with you. More than that is unwieldy. You'll take others with you if you attack from a third of the way down the bunch, less than totally flat out, and close to the other riders. That telegraphs your intentions and makes your back wheel accessible to anybody who chooses to follow. Do it too slowly and you'll achieve nothing more than a little excitement, a slight increase in overall speed, and your sudden appearance at the front of the bunch. Do it too fast and too close and not only can nobody get on but you also run the risk of piling into somebody pulling out immediately ahead of you.

Early breaks are much more likely to succeed in the cold or, even better, if it's cold and pouring with rain. Nobody really wants to race anyway and

a lot will drop out when they perceive there's no chance. Wet roads favour smaller groups because the spray increases as numbers increase. Some blokes at the back of the bunch might not even realise that you've got away.

Brakes work much more badly than usual in the rain, so the bunch can get round corners and down hills far less easily. Exploit the situation as far as you dare. With luck and common sense, the bunch will fall off long before you do.

Hot weather can also help a long break, although not often before half distance. Racing in the heat is nearly as sapping as racing in the rain – but not quite. Most riders will settle down to race among themselves once the break is out of sight. There may be a chase, it may succeed, but you're much less likely to be caught by the whole bunch.

Nearer the finish – in the closing miles, perhaps – you need the support of fewer riders. In that case you attack from nearer the front and ride faster and further from the bunch. You swing violently towards the far side of the road and hold maximum speed for as long as you can. The sprint clears anybody off your back wheel; the switch to the side makes it harder for anyone to latch on.

Hills

Bikes are grand things for the flat, but inefficient on hills. Rolling resistance and wind resistance stay the same. But the energy needed to beat gravity on even a 1 in 27 – just a drag – increases wildly with speed.

MPH	6	10	15	20	22	24
Rolling resistance	6	10	15	20	22	24
Wind resistance	2	9	31	74	99	128
Energy for hill	40	67	100	133	147	160

(*International Cycling Guide*, 1980)

Now, this means three things:

– Hills are excellent places on which to attack
– It's usually enough to increase the speed by a just a mile or two an hour to make life exceedingly miserable for everyone else
– You can move to a more upright position, if you choose, because wind resistance becomes a minor consideration as the speed decreases.

Indeed, if you look at the great Tour de France climbers over the years – Charly Gaul, Federico Bahamontes, Lucien van Impe – you'll see they're all happy to sit higher than usual to give their diaphragm free movement. They can then go into a crouch when the hills tightens into an all-muscle slog.

The counterside is that there's no room for recovery. The demands of riding even a gentle climb are so great that it takes a big drop in speed to repay oxygen debt. That's why riders don't so much get shot off the back on hills but literally get left behind.

On the longest climbs, you've got no choice but to settle in at your most economical speed and hope for the best. If you've got a good power-to-weight ratio, like Robert Millar, you'll do well. If you're big and brawny . . .

British climbs are rarely more than a mile or two. And though they're frequently steeper than elsewhere, the steep bits are also quite short. That means you can tackle them differently.

The rule about being at the front in a bunch is even more important on a climb. The nearer the front you are:

– the more you can control the speed of the climb (because the effort involved in overtaking you is disproportionately great, as we've seen);

Make 'em suffer on a long climb by keeping the pressure on. Note how you can sit higher because the speed is lower. It helps you use your diaphragm.

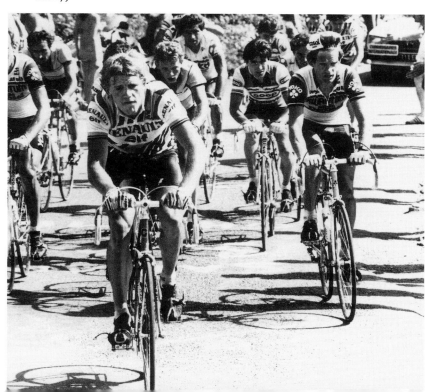

— the more you can slip back through the bunch if everybody else *does* start going past you (in fact, at the risk of being self-defeating, you can do this deliberately if you know you're a poor climber; the energy you save on the climb by riding 1 mph slower could be less than the energy needed to make up the ground on the flat; but you *are* taking a gamble);

— the more you can see anybody making a big effort and respond to it;

— the less likely you are to be held up by poor climbers, muffed gear changes and wallies falling off.

Control the speed at which the bunch takes the hill. Most riders dislike climbs as much as you do, and they'll ride at any reasonable pace. Unless someone is determined to attack, instinct is always to match the rest and survive the climb. But you'll have the greatest influence if you're at the front: there's less benefit to being on a wheel, as you see from the table (and because it's hard to follow a struggling rider too closely anyway), so the front is as good or better than being several rows back.

There's another point, too: very few other people are likely to know you're worried about the hill. If you *seem* to be going well, that's all they can judge you by, and they will. Don't show the strain. Don't grimace. Don't grovel and grind. Eventually you'll demoralise the opposition.

If they do challenge you, take the chance and resist. You'll be dropped if you don't. And there's always a good chance that, having stayed with the attack, you can impose your speed on it for long enough to recover again. Remember, there's a lot of psychology in climbing, particularly on long hills.

On short ones, that's normally all that's needed. On long ones, like the mountain in the Isle of Man, there might be several attacks. Watch to see just how well the established climbers really are going. You know them, but you're more of an unknown quantity. There's no point in their attacking unless they can drop you, and no point attacking harder than they need to. The first probe, therefore, will probably be a feint. If they can get you to blow up then by over-reacting, you'll have done their job for them.

Let them go at their speed and accelerate gently to yo-yo back to them. Put everything you've got into regaining them and they'll just attack again and again until they've worked you over. Then you'll hardly survive the climb.

If you respond gently, there's a chance you'll catch them, there's a very good chance that you'll be tolerably fresh at the summit, and there's an excellent chance that you'll descend faster as an individual than they will as a group.

If you want to make everyone else suffer, though, there are several ways to do it, as well as the feint-and-attack method.

Try rolling a gear briskly into a hill and keeping it going at an even pace all the way up. You'll be shattered, but you should see what it does to the others! The size of the break that develops depends on how long the hill is and how well you do it. The perfect hill for this technique is a pronounced drag of around a mile on a narrow road. If it gets steeper at the top, so much the better. Your body will be begging for a rest, but that steep bit is where you deliver the blow: get out of the saddle and keep going. Get on to somebody else's wheel over the top, recover, and keep the break going.

You can carry this through into a team tactic. The stronger climber takes the hill at a fast pace with his mate on his wheel. The team mate takes over across the top of the climb, with the climber slotting in behind him. A moment's recovery and you're away again.

Never get caught on the inside on a climb. There's no telling what other people will do as the going gets tougher: they could wobble, slow suddenly, slip a gear, touch wheels and fall off. You've got no room for manoeuvre if you're up against the kerb or the verge.

Remember, it's harder to change gear on a climb, because the chain's so tight. You have to ease up, so stalling is a disaster. Ride in a gear that you can keep pushing; don't pedal yourself off the back.

Keep an eye on the gear that other riders are using. A rival on a big ring and inside sprocket will be in trouble if the hill gets harder; on the other hand, he's in a better position to jump on the flatter section at the top.

Milan-San Remo was once won this way. Two riders were clear on the last of the hills that lead to the flat run-in. The first was on his small ring and his second sprocket; the second gambled on his bigger chainring. He spotted that the leader had only one higher gear on his small ring and realised how hard it is to move on to the big ring when the chain's tight.

Out of sight at the back, he eased gently, changed on to the big ring quietly and slipped up the block. Then he attacked hard, going down the block as his speed increased and the hill eased up. He was still going up through the gears as his rival was fighting to get on his big ring.

Moral: look, reason and act!

Descending

We're restricted here by other traffic on the roads. There are even dangers when there's nobody about; somewhere I've got an old *Sporting Cyclist* with a picture of Jim Hind's bike in a Tour of Britain thirty years ago. It's got a 10-inch wheelbase and a heavily modified frame after he hit a sheep in the Pennines.

Descending is important when:

- You're trying to stay clear or regain a break
- When it's just you and a better climber, because good climbers are often poor descenders, for some reason
- When the descent is followed by a complicated route to the finish a few miles on.

If it's you and one other and you might get clear, give it a try. Don't take risks, but see how far you can stretch him. He may be a poor bike handler. He might just remember it's a long time since he checked his tyre cement.

British races are led by somebody's father driving a car with its headlights on. It's supposed to warn other road users and protect you, but it can be dangerous on a winding descent. In the Tour, they send the lead cars miles ahead in the mountains because they can't descend at a bikie's speed; other people's fathers realise this only too late and you'll start closing in alarmingly fast on the back bumper.

There's not much you can do but shout. There's certainly nothing to be gained by trying to go past; the only place it's safe – on a straight – is the very place that the car can accelerate away from you.

To be fair, the problem's not solely a British one. I was once in a professional team car that brought down three highly-important European stars in one of the Belgian classics, for precisely the same reason.

You're pretty safe if a motorbike's leading you, though. Good organisers send the warning car well ahead and give each group a motorcycle outrider. A motorbike takes much the same line as you, so – leaving aside the question of oncoming traffic – you can follow its line.

Remember the other rules for fast descending:

- Don't go to the front on a strange hill – stay second or third
- Don't be at the back of a group – crashes are even more painful at speed
- Don't ride on a wheel – leave at least two lengths
- Don't crouch into a low, streamlined crouch – you can't use your weight on the bends
- Descend on the drops where you can reach your brake levers, but go on to the brake hoods where you can see the way ahead – you can still crouch low, but sitting high will give you gentle braking
- Wear sunglasses or even goggles to protect your eyes – grit could be disastrous
- Keep turning your legs slowly on the straights, but put your weight on the outside pedal on bends
- Always use both brakes – it keeps the rims cooler and the back brake keeps the bike in a straight line as the front brake starts to bite

— Don't keep the brakes on lightly all the time or you'll melt the rim cement.

Chasing

A chase is an attack that goes too late. Exactly the same rules apply. You have to launch a counter-attack to form a useful group smaller than the remains of the bunch. So far, it's just a counter-attack.

The point to remember, though, is this: when groups merge, they slow down. It's a defeat for the breakaway; it's a moment of triumph and relaxation for the chasers. For all of them it's a period of reorganisation. And, of course, there's a strong chance that the new group will be unwieldy again.

None of this matters if the new group is so far ahead of the chasers, and so far from the finish, that it won't get re-caught and that there's time for new attacks. This leading group will have become the new bunch and the rest of the race a load of stragglers.

But consider the position if you have three groups just thirty seconds apart. You'd have the *bunch* hammering after the *chase*, hammering after the *break*.

Any of those groups will slow if it merges with another one. The bunch will catch the chasers and therefore fail to catch the break. Or the chasers will catch the break and let the bunch absorb them. There's nothing the bunch can do because it's *got* to catch as many riders as possible to get back into the race. But you might want to consider letting your chasing group approach the leaders but hold short of actually catching them. That'll keep the break going hard and sustain your chase enough to keep the bunch at bay.

You can keep this going for many miles, but of course you have to do something about it near the finish. By agreement you can move up on the break or, unannounced, you can try jumping across. Which you choose depends on where the established sprinters are hiding. Take them across the gap and you're at a disadvantage. You may blow badly in your effort, but then you'd be beaten by the sprinters anyway.

Lone attacks and chases are the stuff of which heroes are made. It's a classic way of winning, alone, with your arms aloft. It's risky, but the rewards are exceptional and there comes a time every so often when it's the sensible thing to do. On a tough hill, for instance, there's no point in being on a wheel, and you'll descend faster on the other side, particularly if the surface is wet, winding, badly-surfaced or just plain dangerous. Remember, though, that it's not called a do-or-die effort for nothing.

Disruption

When there are big professional teams and a lot of money and kudos hang on the result, there is some point in carrying out negative tactics – disruption. Your star rider might be back in the bunch; or your star rider might be clear and his nearest rival is getting ideas about setting up a serious chase. It's legitimate in cases like that.

Unfortunately, some people get the idea that it's worth while in a third-and-junior 40-miler with a £5 first prize. Either they disrupt a chase or break because they fancy they're helping Bert the Club Champion, or they fancy their own chances and they sit in and do nothing until the final sprint comes. Either way, their presence is disruptive.

If I tell you how to do it, remember this:

- That positive tactics – remember Ken Matthews and his Kirkby riders – are always better
- That you have to be fit enough to win if you want to disrupt a race properly
- That other riders will get justifiably angry if you soft-shoe your way to the finish and win and they'll gang up against you for many races afterwards.

Don't disrupt a race for the sake of it. Even in the Tour de France, with the most experienced riders in the world, the teams depend on their managers for direction. The bigger and more evenly balanced the teams, the less you're in a position to make judgements for yourself on the road.

Imagine, though, you've got away in a break during a stage race. Your best-placed rider is still in the bunch. There's no problem if everybody in the bunch is poorly placed overall and the lead on the road doesn't grow dangerously large. You can try to win for yourself.

But imagine that your mates in the break are better placed than you are and also only a minute or so behind your star man. There's no point in your trying to win, even if it takes you up a few places on general classification, because you'll take your rivals above your team leader in the process. It's also not worth dropping back to help your leader chase because you'll be strengthening the break and weakening your overall team position. So you have to stay where you are and do nothing to help and all that you can to hinder.

The break will have settled into some pretty earnest bit-and-bit. You'll have to join in because, if you don't, you'll get dropped. But now you face a riddle: how can you join in without increasing the lead? How do you share the pace but keep the speed down?

Well, the break of course will be watching you, because they know

what's on your mind. You could refuse to go through in the pace-line and just switch from back wheel to back wheel at the end of the line. It will make you incredibly unpopular, though, and you'll invite immediate counter-measures. I'll come to those in a moment. They'll understand why you're doing it, but they'll be doubly angry if, still fresh, you go on to win the sprint as well.

Anyway, not taking part in a pace-line makes very little difference. You can lose one rider in a group of six with no appreciable fall in speed. So you've gained nothing.

Now you call on bluff. It's hard work and there's no guarantee it'll work. You have to persuade your break-mates that you've decided to defend your own chances; you have to convince them you're taking your share of the work while in truth you're making things tougher.

So how do you do it?

— You could do your turn at the front but not ride especially hard, but that would soon be obvious. They'll soon apply counter-tactics;
— You could go to the front and ride at full effort, but for a longer turn than normal; this is tiring, so you start slowing and lower the average pace. You also spoil the rhythm of the line. What's more, the bloke who should be sheltering on your wheel when you pull over gets much less shelter than he should;
— You could take your normal part in the line but accelerate as you go to the front, and swing over immediately. Again, this is tough, but it's convincing because it seems you're not only not slacking but actually trying desperately hard. The effect, of course, is a lot of breaking of rhythm, a hard ride for everybody in the up-line, and a whiplash effect on the end of the down-line.

Handling disruption

The simplest thing is to do nothing. Disruption is hard work and needs mental discipline. He has to study you for the effect he's having; if nothing happens, he may give up.

Don't shout, gesture and bully as a first measure. That just convinces him he's having the desired effect. The thicker his skin, the more he'll persevere. Ride round him whenever you can or, if he hammers through at the front, refuse to accelerate with him. Your speed will stay the same but he'll exhaust himself. Certainly never get out of the saddle, because that's just what he wants.

The next stage is positive action. Here there are two circumstances. A rider with two members of another club will reasonably do less work

nearer the finish because the other two will have the advantage in a sprint. The other is a rider in a larger, mixed group, who refuses to leave the back of the line.

First circumstances first: to get rid of an outsider, take turns in attacking. He'll have to respond to every attack; if he doesn't, the best he can come is second. Yet if he lets one of you win, there's always the risk he'll only come third.

If he responds, on the other hand, he knows you'll switch on to his wheel and stay there either until he catches your clubmate or blows up in the attempt. It's very demoralising because he knows that the moment he catches your mate, you'll take your turn to hammer up the road and he'll have to do it all over again.

Now the second circumstance (which can also be used in the first example): it's hard for rivals to attack in turn because too many people are having to concede first place. On the other hand, provided the group promises to stay together, you can begin taking the loafer off the back.

Since he insists on staying at the back, the last but one rider lets a gap open in front of him. The loafer has to close the gap, taking the other rider with him. The bit-and-bit then revolves one place and another rider takes him off the back, and so it goes on.

Eventually the sitter-in will be too shattered to get back. When that happens, the break eases and the tactician sprints back across the gap. It might take frequent attempts, but it'll work in the end, if only in seriously weakening him. There's no way to deal with being taken off the back except to launch an attack of your own and show repentance.

The one remaining way of making things hard for an outsider depends on a crosswind and your sense of distance. You simply make an echelon and don't leave room for him. You start the line six men from the kerb so that the seventh has to go to the outside. If he tags on, you rotate the line until you get him back on the outside, at which point you stop rotating. But note two things: you can only do this with right-hand winds if the road's open to other traffic; and, probably more significant, it's incredibly difficult to explain to everyone what you've got in mind without tipping off the rogue rider as well!

Psychology is often more effective than the actual tactics. If he's strong enough to hang on regardless of the rough ride you give him, there's not much more you can do. But remember that he's already under some stress so, if all else fails, try constant abuse. If nothing else, it'll upset his concentration.

6 Grit your teeth and gallop

It's unknown for a modern race not to have a sprint somewhere, even if only for tenth place. The days when sun-burned riders pedalled alone through the mud of northern France to win a Tour stage in darkness have long gone. So you might as well get the hang of it.

In any ten riders, nine say they can't sprint. What they mean is that they can't sprint as well as the specialists. And yet there are precious few specialists. Even the Tour de France has only one or two from each country.

Watch the finish of a flat classic and you'll see the professional teams trying to get their sprinters into perfect position. Trains of riders set up within the bunch, keeping the pace frantically high to stop attacks going, but at the same time keeping the star sprinter sheltered. Then all hell breaks loose with about 200 metres to go.

Watch and you'll see the trains break into threes. First will be the lead-out man, who's giving his star a flying start into the last hundred metres. Then will come the sprinter, who'll burst through when the lead-out man eases to one side. And third will be the guard, who'll stay on the sprinter's wheel for as long as he can manage with the aim of stopping anybody else getting on it instead.

You won't get sprint trains going in Britain, where your average team's only got three riders, but that's still the way a perfect road race sprint is conducted.

Oh, and a point to say now: never sprint for the finish banner. The officials hang it between two convenient lamp-posts, not necessarily directly over the line.

You can do a lot in a sprint finish by using your head. Remember that sprinters like to get to the finish fresh and that, being often quite bulky, they're generally rotten climbers. So:

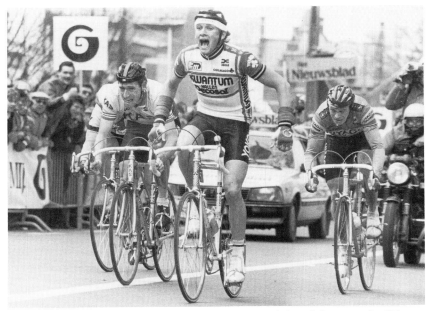

One jack-rabbit outruns another. Van de Poel beats Sean Kelly in the Tour of Flanders.

— You're less likely to get a sprinter in a small break because he'll have to take his share of the work; or if he doesn't, he'll know he'll get worked over;

— A sprinter's chances increase as you approach the line. He won't need a lead-out in the last 100 metres, so don't sit there too long waiting for him to make his move, or it'll be too late;

— You have more chance of winning a long sprint against an established sprinter if you've got the wind behind you (less advantage to being on a wheel), if it's downhill, or if the finish is at the top of a hill;

— You can upset a sprinter by making the last miles very erratic; sprinters prefer an even and very fast run-in to the closing metres;

— You can box the sprinter in at the finish, although no decent sprinter would ever get himself into that position and, even if he did, he'd barge his way out of it with his bulk.

Sprinters are great tacticians, but they employ different tactics from other folk. They are generally more worried about each other than they are about you. Sprinters are also rarely all-rounders. They have just this one speciality. So it's worth going for a long sprint, or a late break, because you'd get beaten anyway if you'd left it to the sprint.

If there are several of you working against a sprinter, wind up the pace from several miles back. Do all you can to keep him in the wind — small echelons or pulling to one side when you've got him on your wheel.

There's just one tactic left to you if you get to the last 200 metres with a sprinter on your wheel. Wind up fast along the kerb, so that you keep him firmly on your wheel. Anticipate his final jump by moving a couple of feet out in the road. He can't come round you, so he'll have to come between you and the kerb, the fencing or whatever. You just move back partly across the gap as he starts to jump. Then, as he brakes, swears and loses momentum, you jump again. At the same time, you'll have scared the wits out of anyone on *his* wheel as well.

This isn't dangerous and it's not against the rules – provided you leave him plenty of opportunity to brake. It's potentially lethal if you just shut him out completely and you'll be both disqualified and, some time later, he'll wallop you one.

If you shut the gate on him and he gets round on the other side and still beats you, well, congratulate a better man.

It's a great delight to reach the finish without an acknowledged sprinter. It straightens out the tactics wonderfully. It means you can concentrate on facts such as:

— It's more or less impossible to win a downhill sprint from the front; wind it up fast from the back, come by wide, and be going at a mighty lick before anyone realises what's up;
— Equally, you have to be very strong to lead out in a headwind; that means the sprint starts late. It also means that, if you feel very strong and you'll risk a do-or-die effort, an early attack can occasionally succeed;
— It pays to take the first chance you can in a tailwind finish; every mile an hour of following wind means that much less benefit to being on your wheel and you're more equal. Two or three lengths is often practical;
— There's much more equality in races with limited gears, above all downhill or with a tailwind; you may get smoke emerging from your chamois, but it's pure pedalling speed that'll count;
— An uphill finish is just a gamble. Late attacks favour the strong, whose extra muscle will provide acceleration but for whom their extra bulk isn't a problem on the shortened distance; early attacks favour the lighter riders, but the lack of speed means you could be giving a free lead-out to whoever fancies it. Sorry, there's no firm rule.

Get in your ultimate sprinting gear around 400 yards (350 m) before the finish. That'll cover you for all possibilities. It may pay you to go early if you sense the slightest lull; most of the rest will be expecting to wind-up at 250 yards (200 m) and the full-out sprint at 150 yards (130 m).

Unless you're on restricted gears or hammering downhill, don't sprint

in your smallest sprocket. The first reason is the obvious one that it doesn't give you the chance to change up if you find yourself undergeared (it's out of the question to change chainrings in mid-flight). The second is that there's too much friction because the chain is out of line; and the third is that it's tougher to change down if you're over-geared.

If you have to gamble on a gear, gamble on the lower one. It's always easier to change up than down.

A super-sprint starts a few miles out. The field goes into a long line of people feeling very miserable indeed. From that line can come attacks on either side, do-or-die efforts that just make things more painful. Listen, watch, anticipate. Switch from wheel to wheel all the time to suit you best, but never lead if you're an ace sprinter. Watch for boxes and for being leaned on. Stick your elbows out and keep an elbow's distance from everyone else.

You only get one chance in the last 200 metres.

Brainpower

Look, watch and think — constantly. Remember that fast races run everyone to their limit. Fatigue shows, lack of concentration is costly, and exploitation is valuable. As Jack Simes put it:

> Even being a good actor can help you win a race. Once I was in a final breakaway with several other riders who were fitter than I was at the time. They were sprinting for the primes but I was saving everything. I was so tired that if they had made an attack I would have been finished. But they didn't realise that, because I didn't show it.
>
> I tried to look fresh, like it wasn't bothering me, when all the time I was aching inside. By hiding my condition and pretending to feel fine, I managed to make it to the end and beat them in the sprint.
>
> The way to prevent the other riders from knowing when you are suffering is to keep your mouth closed and look alert. Inside, your guts may be falling out, but you look as fresh as a daisy.
>
> Sometimes, on the other hand, it's beneficial to appear tired. You can pull a lot on your bars and wrestle with your bike. Breathe hard and try to look red in the face. People will notice this. They are watching and their eyes are flicking around all the time.
>
> If another rider really knows what he's doing, he can make it hard for you to tell how he's feeling. But if you're dealing with someone who's not quite in shape, for example, you can listen to his

breathing. Compare it to your own breathing and see if he's taking shorter or faster breaths . . .

The old roadman Fred de Bruyne, in the days when he commentated on road races for Belgian television, became famous for insisting: 'Look at his feet, look at his feet . . .'

He rarely said why, perhaps because a nation knowledgeable about their national sport didn't need the explanation. The truth that went unsaid is that jerky pedalling and a marked change in foot angle are an early sign of fatigue. So is a rounded back and eyes that stare down at the road or at the wheel immediately ahead.

Keep watching and assessing. Attacks in strategically bad places can succeed merely because the man to be attacked was boxed in or wasn't looking.

When things go wrong

Racing tyres are fragile things. They go down for everybody, but mostly for the bloke who rides clapped-out old things that have already been

Misery! Let the service mechanic see precisely what you need done – and make sure you're on the same side of the road as the service car.

mended a couple of times. I don't think there's much you can do to stop it happening, except to stay out of the gutter and not ride particularly light tubs if you weigh more than 10 stone.

You don't need to be a mega-star to win after puncturing, but you do need a couple of team-mates and a service car to be sure of a chance. Spare tyres under the saddle are just for riding back to the changing rooms in single-day races.

Stick your hand up as soon as you know your tyre's going down. Usually it'll go down slowly and it could be some time before the service car can get to you. Get to the left-hand side of the road and keep pedalling for as long as you can, dropping back through the bunch. Put your left hand in the air for a front wheel, your right for a back wheel. Repeat the signal as you get to the back of the group. If you can't remember which is which, think of the hand you use to operate the gears – left for front, right for back.

If you want to help the mechanic, hold up all five fingers for a 5-speed block and just one finger for a 6-speed. Put your punctured rear wheel on to the small sprocket. Move into a get-away gear if it's your front wheel.

Then stop, undo the brake quick release, and take out the punctured wheel. Stay on the bike for a front wheel, with one foot still strapped in the

Let the mechanic do his job without interfering – right down to getting you on your way afterwards.

pedal, but get off for a rear one. If the service car was down the road when you punctured, lift the wheel in the air, block side towards the car.

Let the mechanic do his job. Don't wallop him if he fumbles, which is the treatment I saw a Polish mechanic get. No-one will change your wheel deliberately slowly but you'll slow things down by getting angry. I once saw Eddy Merckx lose nearly a minute because a mechanic got stage fright.

You can get back to the bunch if your team-mates drop back and ride gently at 200-yard intervals. Sprint to the first, let him pace you to the second, the second to the third, and then all of you to the group.

You can't do this if you're in a caravan of cars, because they get in the way. In this case, use the cars to get back. Sprint to the first car, recover on the edge of the bumper (not in the middle, where you're blatantly taking pace), sprint to the next, repeat, and carry on to the front. Most commissaires will raise no objection provided you're sheltering rather than taking pace, if you see the distinction.

Big races have radio links and the drivers will know you're coming up. Sometimes, too, they'll hoot to warn the guys ahead. This works both ways because rival teams' drivers will sometimes leave longer gaps to make it tougher for you. You can't complain; you'd probably do the same.

Finally you've got the gap from the front car to the first back wheel. Pray that the commissaire's kept it to a reasonably short distance. A hundred yards is a very long way when the bunch is going beserk and you've already had to chase back from a puncture. But you've got to do it, so do it.

Remember that the commissaire leads the service cars. The cars can't pass without his permission (that's what the curious lollipop signal is that they use on the Continent – a badge of authority and instruction). So, if there's a pile-up or a major rival punctures, attack at once. Get into a break and for a long time you'll have no cars following you. The commissaire won't come up to you or let the service cars go by until you're so far ahead that following cars won't help close the gap.

That means that riders fighting to get back have to close not one gap but two, the second without the help of slow-moving cars. If, as can occasionally happen, Sunday drivers not connected with the race get between the bunch and the break, well that's hard luck, I suppose. But it's a rule worth remembering.

7 Just like the army

The only person I can think of who ever won the national road race championship and the best all-rounder competition in the same year is a chap from Leeds called Arthur Metcalfe. A year or two later he was riding the Tour de France, which is a very long race indeed.

Halfway through, word got round that part-time professionals like Arthur were riding in their summer holidays – which after a fashion they were. When as a consequence one of the reporters asked Arthur how he was finding it, he said: 'Just like being in the army; up every morning on parade, marching about all day, and then knocking off again.'

Most stage races in this country are just two road races and a short time trial, cobbled together over a weekend. The longest common stage races may be at most three days long, over a bank holiday. But the longest, the Milk Race, is around a fortnight.

Anything longer than two days certainly isn't for beginners. The reason is partly because your wheels are big gyroscopes. An exhausted footballer or hockey player falls over before exhaustion can do any harm, but a bike rider is held up. More proportionate effort is going into the primary activity than in supporting the body, so that riders at the end of a tough race can sometimes scarcely stand. The spinning wheels keep you going, literally, too far.

This tiredness isn't harmful, but it is tiredness all the same. And it builds up as the stages amass.

Stage racing requires organisation, both by the riders and by their manager. The longer the race, the more necessary the manager. But you can also make a big difference. The strain, for example, of leaving a sock in each stage town is higher than you'd think, so you have to be pretty good at living tidily out of a suitcase.

The riding technique is more tactical. You have to concentrate and get

to know the riders who present the greatest threat on general classification. Some riders write their rivals' numbers on the inside of one arm. You have to know when to let minor riders have their head, because they present no threat; you have to know when to attack, when to defend, when to exploit others.

You also have to read the rules carefully to see what bonuses are on offer for stage winners and primes.

Organisers love including a time trial. The longer it is, and the earlier it comes in the race, the greater influence it will have on general classification. The reason is straight forward: road races can finish in a bunch with every rider placed in the same time (indeed bunches are clocked that way to save dangerous riding; the timing may even be taken at the start rather than the end of the finishing stretch). On the other hand, time trials can separate riders by several seconds which are almost impossible to make up in a short stage race. The race leader has only to stay with the runner-up on the remaining stages and he'll keep his lead.

There's nothing much you can do about this, except attack a lot and point out the organiser's folly.

It's different if the time trial is the last stage, though. Then you have to guess how much time you'll lose on the fastest rider, assess who the most likely winner is, and then ride accordingly. It's a real gamble if there's not an obvious front runner, but there's more scope to influence the result.

If the time trial starts the race, you're attacking specific riders to close known differences. It's difficult, because the leaders know who's likely to attack them. But with a closing time trial, it's much more important to get in the final break and to work it to as big a lead as possible. It's hard luck if you take a good time trialist with you, but at least you'll have left the rest.

You can work over a good time trialist in the same way that you'd treat a sit-in sprinter, but you'll probably have to do it more often. Time trialists often lack a jump, but they can, by definition, often cruise their way back on.

The finish bonuses become crucially important if you take a time trialist as far as the last 200 metres. The few seconds might just be enough to displace him, particularly since time trialists aren't famous sprinters.

If you're the time trialist, the trick is to play it the other way round: riding defensively and going with the breaks. You can afford to work with the break because its gains are also your gains. It doesn't matter too much if you get outsprinted, provided you can regain the bonus in the time trial. Remember, by the way, that sprinters are often good short-distance (two or three miles) time trialists as well.

There's a distinction between a stage race and a tour. Club events are stage races. Tours are stage races as well, but they go on for a week or

more. That gives you and your manager time to work out a strategy, time for things to go wrong, time for other teams' strengths and weaknesses to become apparent.

You'll realise, too, that you can no more have a team made up of good one-day winners than you can have a bunch of tour specialists all desperate to win. Some of that applies to club stage races, too, if the teams are allowed to be big enough. Somebody has to be a chief; most have to be indians. If, for some reason, two or three change positions, well okay, but you can't all win.

At times, important races have been won from the first stage. The Milk Race and the Tour de France have gone that way. More usually, though, blokes who want to win lie doggo for first few stages. Wearing yellow makes you an Aunt Sally; you have to defend everything. Many riders have spoken honestly about being relieved that they've lost the thing.

Stage race winners rarely come from sprint specialists unless the course particularly suits them. Equally, you can't win a long stage race if you can't climb. And then, although riders have done well with weak teams – it's happened to Sean Kelly – the support has to be there. That's why professionals with sense turn down mega-contracts from teams that pay their supporters peanuts.

You'll have a team car in a stage race – and your manager has an overall view of the race, as Sean Kelly discovers.

The time to make a go for the lead is about a third of the way through (provided the race is more than a weekend long, of course!)

Once you've got it, you've got to defend. In some teams, that means attacking all the time. It's the best way if it works and if you can sustain it as a team. It has a great demoralising effect on the opposition when the leader keeps giving them a hard time.

But it's more usual for the leader to go with important breaks and then let others do most of the work. After all, unless the break will take him away from his closest rivals (left behind in the bunch) he has nothing to gain.

Don't be a prima donna if you happen to be your team's best-placed rider. The others will defend your chances and work for you, but in many cases they could have won for themselves. The time will come when positions are reversed.

A team-mate's job is:

— To keep the pace high to discourage breaks that don't include the leader
— To make early, silly breaks that wear out the opposition
— To stay near the leader all the time if his bike's much the same size
— To lead out and watch his back wheel in a sprint if necessary
— To pace him back after a crash or a puncture.

You have to be an arithmetic expert in a British race. In a big event, the team cars will be keeping an eye on progress, listening to the race radio, and giving you instructions. Peter Post even had a dashboard television in the Raleigh car so that he could watch the race as it progressed. Here, though, the most you're likely to get is a motorcyclist with a blackboard on his back. On it will be the numbers of riders in the break and the length of their lead. From that you have to plan your tactics. It's not easy, but it's no easier for anyone else.

This is a book for ordinary riders, not for tour riders who have managers working with and for them, so it's not the place to go into long and detailed instructions about tactics. But it is worth mentioning the thing that causes most irritation in tired riders: prize money and the way it's shared.

The best system that I've ever come across, and one that I've always applied, is one used by one of the Dutch sponsored-amateur teams. It's simply that you keep 20 per cent of everything you win and pool the rest (including yourself in the pool, of course). It doesn't matter whether somebody does nothing all through the race — he still gets his share. He just gets thrown out of the team afterwards. The share goes to everybody who started the race that day. Simple as that. The effect is that there's a

reward for finishing in the prizes, a fair reward for the equally tough job of support.

You might also like to consider including the manager in the cut. He has, after all, given up his time and his expertise to help you win your prizes.

Now to other matters. You have an extra responsibility in a team race. Everything that you do wrong affects everybody else. They have to get you back if you ride dodgy tyres and puncture. They get held up if they get one of your spare wheels in a service change and find that it's non-standard.

It's important for every wheel to be well built and shod with good tyres. Use 36–36 wheels with three-cross spokes and supply a spare pair for service. Your spare wheels should have a standard close ratio block, 6 or 5-speed according to what everybody else rides. You can put your 'hill' block on before the tough stages, but all along the road the spare wheels should be identical and compatible with all your bikes. The quick releases should all work immediately on any frame in the team, without further adjustment. Ride them for a couple of hundred miles before you race on them if they've just been built. Don't glue the tyres in place on the night before the race.

You can go into a weekend stage race with no particular physical preparation. It's no more than a normal weekend's racing, the distance of one day reduced to accommodate the inevitable time trial. It may be harder mentally, but physically it can often be easier than two straight road races, one on the Saturday and one on the Sunday. Most seniors can cope with that.

More than two days, and especially more than four, is a different matter. You have to go into a tour fresh. There have been riders who say they preferred to start slightly overweight, or slightly unfit in other ways, so that they ride themselves to fitness in the race.

What they're actually doing is getting the answer right but confusing cause and effect. In getting to a stage race fresh, you have to reduce the intensity of your training. The riding period each day should still be approaching the average time duration of the stages, but you ride for time at reduced output and not for speed. Therefore it's inevitable your pure fitness will decline a little. The pay-off is that your mental alertness and your sheer longing for competition will increase.

Don't overdo it. It's not carte blanche to go lounging about and cutting your training right back. You've still got to train and, by most people's standards, train hard. It's just that you need to rinse away all the strains, drains and anxieties of normal stress. If you feel guilty, just tell yourself — because it's true — that it's impossible to recover totally during a hard

stage race. You've only got to check your pulse morning after morning to find that. And tales of classy riders having to come down stairs backwards because their thighs hurt so much are genuine. I've seen it happen.

Consider your strengths and weaknesses carefully. Can you improve your climbing (more important than a sprint in most stage races)? And how about your sprint? Why not consider specialised training in jumping from group to group?

And golden rules for looking after yourself:

Drink, drink, drink – not a lot at a time, but constantly all day, on and off the bike. Let's say the stages are all 80 miles long, fairly short by tour standards. That's still three and a bit hours of constant sweating, day after day. It doesn't matter whether your clothing feels sodden or merely damp – you've still sweated continuously.

Blood is a water-based fluid and it's from there, in the end, that you start drawing water for cooling. Then your blood thickens and you start going really badly. In the end it'll kill you, and even that's happened in cycling. Excessive body heat also causes stress, which in turn either slows you down as you try to recuperate or makes you hotter still as you recuperate.

It's not especially important what you drink provided it's not alcoholic. Some people add commercial preparations such as Gatorade to their bottles. The firms that make them claim that they have exactly the right

Drink little and often, because you're losing fluid all the time. Deborah Shonway celebrates finishing the Tour Feminin – with mineral water.

amounts of salts, sugars and other chemicals to replace what you've lost. Others say the powders upset them.

A sugary solution can be good but often unpalatable. That's why some riders – Freddy Maertens comes to mind but there are plenty of others – shake Coca-Cola until it's lost its fizz and then pour that into their bottles. Coca-Cola is loaded with sugar but the flavouring hides it. Cold, very weak tea with sugar, or well diluted orange squash – they're both worthwhile, both ways of hiding the cloying sugary taste.

Or, in the end, you could settle for just water. The advantage is its simplicity and the option it gives you of tipping it over yourself on hot days – provided you can get some more quickly.

Whatever you choose, never guzzle it, however thirsty you feel. Sip steadily. Don't ice the drinks on hot days – the contrast is greater than your insides will like. It's better to drink something hot than it is to have something iced.

In every two hours of a hard stage race you use as much protein and as many calories as a sedentary person uses in a whole day. Those charts which tell you that cycling at 13 mph uses 660 calories an hour don't say what happens at 25 or even 35 mph or on long mountain passes; one estimate is 1,200 calories an hour. Against this, remember that it takes only 90 minutes of continuous hard exercise to use all the carbohydrate stored in your body.

This gives you something of a problem. You can replace the fluid, but there's just not time to replace the energy. That's why you don't recover thoroughly. It's also why you've got to keep eating for the following day, and eating easily-assimilated food. The old Continental professionals' habit of eating steak after steak has a certain romance and folklore about it but also an awful lot wrong.

It is sweetness, disguised or otherwise, which replaces calories. Kendal mint cake, fruit (especially fruit in syrup) and sugared drinks will do it. Note that there's nothing stodgy there. At a time when you're dehydrated and your digestion is only partially working, stodgy food would just give you constipation and a whole new set of problems.

Warm down after the race, go for the brief ride that will disperse the body toxins, shower and change and then eat as soon as you can. Eat a conventional meal, as close as you can to what you're used to, with plenty to drink. It used to be thought that it was best to wait at least three hours after effort before eating. But that's just another three hours in which you're suffering and not recovering.

You need a high-protein meal after a race if you've been careful to drink or eat sugary things during it. The proteins rebuild muscle broken down by exercise. That's essential. Milk is a good protein drink. Later in the

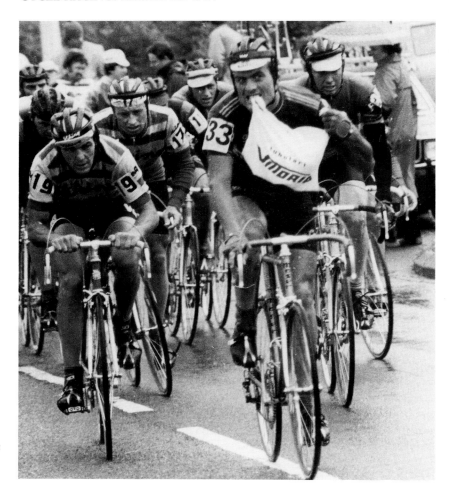

In a stage race, you're eating for the next day. Phil Edwards shows commendable enthusiasm for the contents of his food bag.

evening you should eat sugary food again – sweetened hot chocolate and two slabs of cake – to build up your glycogen reserves again. Avoid eating fat, which is difficult to digest and a complicated way of getting energy, even if it is high in calories.

You'll get all the fat you need in a normal diet without having to eat junk hamburgers, chips rather than boiled potatoes, or fried rather than poached or boiled eggs. It's the fat, after all, that gives many things their taste. It's there all the time.

Eat until you feel on the verge of being full and then stop. You've eaten too much if you feel like rubbing your stomach and saying, 'Hey, that was a good meal.'

Above all, you need rest. Once, when the Milk Race stopped off somewhere a few years ago, there were complaints from other folk at the hotel that there were hooligans and flashers about the place. The hooligans and flashers, as it turned out, were one of the British teams. Individuals were accused of running down the corridors naked or only partly dressed, and of squirting water pistols at other residents. I don't know what it did for the reputation of the sport and the race, but I can only assume that it did nothing for their recovery.

You use up so much of yourself by racing that you deserve to rest afterwards. Absolute, total rest. Shower, eat, massage (if it's available) and sleep. I know high spirits are all part of it (I stayed with a professional team in the West Country once where the team sprinter arranged a 5.30 am call for the team manager), so you don't have to be a killjoy to succeed.

Leave other people to do their jobs. The manager will collect the results, make the arrangements, handle decisions and make protests; the masseur will look after your muscles and in good time; the mechanic needs only to be told what changes to make – he doesn't need to be supervised as well. Let them get on with it.

Nervous exhaustion is a big grind. Sometimes you can get too tired to sleep. You stay awake all night and then fall asleep three hours before breakfast. A massage will help. So will something that'll take your mind right off racing. I had to laugh when I heard that Eddie Borysewicz got himself to sleep with an English grammar book. Eddie is the Polish exile who did so much to take Americans to the top in recent years. Sadly, but to his own and everybody else's amusement, he knows more about bike racing than he does about the language. That's what you need – something to take your mind off the bike.

Go to bed half an hour before your usual time and read, or write letters, or play chess (if you're brainy) or draughts (if you're like me). It doesn't matter – anything but cycling. Don't listen to pop music (remember old Mohamed's funeral?) or watch television (too difficult to turn off). Respect other people's need for silence. And turn off the light at the same time each night. Similarly, discipline yourself to getting up at the same time every morning, within minutes of waking up naturally.

Never, never, never take anything to make you sleep.

Tell yourself that everybody feels nervous before and during a race. And then try to forget about it.

8 Against the clock

If you've read this book's companion volume, *Cycle Racing: Training to Win*, you'll know that fitness is a combination of factors: speed, strength, skill and stamina. I won't go again into just what counts highest for each part of the sport, but I will say that time trialling is unique: it's the only one for which skill is the most important.

A lot of people have giggled at this over the years, but have then been convinced. The mistake they made at first, of course, was to assume that skill was the *only* thing you needed. It isn't. It's just the most significant of the four.

After all, you don't need exceptional strength because there are no accelerations and no hard climbs; you don't need incredible speed because time trialling is consistent cruising, very slow compared to the peaks of track or road racing; and although you obviously need stamina, you're not forced to recover quickly because you don't drive yourself to your limit. You may think you're riding like an express train, but the truth is that at any time in a time trial, you could sprint a little faster. What you can't do is hold that sprinting speed to the end.

That's why skill counts highest – the skill of pace judging. Once you can match your assessment of your maximum cruising speed with the degree of fitness that you've reached, you've cracked it. You'll burn the last ounce of energy on the last yard of the course instead of heaving up two miles from home.

It follows, therefore, that you need great concentration. You also need repetition. All those scientists who've got people doing silly things against the clock over the decades have found that the more you do something, the better you get at it and the less energy it takes. In time trialling, your brain learns the distance, gauges your ability, and applies itself to the task. Each lapse of concentration, therefore, lets you slip over or under your ideal

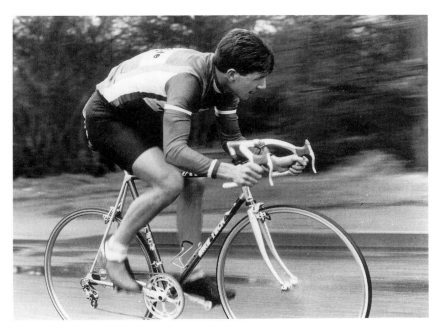

Once you've got it going, keep down, keep pressing, and concentrate, concentrate, concentrate.

cruising speed. That, apart from the added hindrance of extra rolling resistance, is why you slow down on a bumpy road; your concentration is broken by the bouncing and jarring. If, on the other hand, you go over your cruising rate – by sprinting out of a corner or going to pieces on a hill – you go into oxygen debt and your recovery takes considerably longer.

Now, you don't need a boffin to tell you that it's easier to concentrate on slow movements than rapid ones. That's one good reason why gears have grown higher in time trialling than other parts of the sport. Track gears have risen no more than a few inches in several decades. In the same period, top-rate time trialists have gone from single-fixed gears of around 88 inches to a highest freewheel of perhaps 110 inches.

At the same time, the rise in performance has been considerably less than proportional, so that the increase in concentration has obviously been offset by lack of strength. At one time, time trialists were using gears so high that their legs were lifting their backsides off the saddle instead of getting the pedals round. Even so, the logic is born out elsewhere – on the track, for example, where pursuiters use a higher combination than sprinters. Their concentration period is longer, the risk of interruption infinitely less.

The high spot for rows about gearing was in the seventies, when an eccentric but knowledgeable senior coach called Peter Valentine led a

crusade for faster revs. It made his day when riders like Dennis Brown of Portsmouth momentarily reversed history by winning championships on small gears, their legs blurring. But since Peter's death, the battle has been almost unfought. At the same time, the extremes of big-gear pushing have also burned themselves out and we've returned to a period of relative reason.

Whatever the gear, you've got to turn it to produce a speed which seems slightly uncomfortable. There's no progress without extending yourself and a comfortable speed is always a slow one.

It's a purely mathematical relationship, so once you've settled on an ideal pedalling speed, you can calculate how it would vary if you changed your gearing.

You start by finding the revs you're doing in the gear that you use for most of the time:

$$\text{Revs per minute} = \frac{20160 \times \text{the distance in miles}}{\text{gear} \times \text{time in minutes}}$$

Then you can move to the time you'd do if you kept the revs the same but changed the gear:

$$\text{Time in minutes} = \frac{20160 \times \text{the distance in miles}}{\text{gear} \times \text{revs per minute}}$$

The start

Get to the start only once your minute man has left. Be sure your bike's exactly in the right gear for starting — a gear high enough to push away from the start, but not so low that you need to change up almost immediately. Don't use an extreme chain angle or you'll be one of the several riders each morning who crunch their gears in the first yard. And do make sure your rear quick release is tight enough to take your starting effort.

Take two or three medium breaths before you settle down on to the drops, but don't go into a deep-breathing routine. There's some evidence to suggest that artificial deep breathing upsets the exchange of oxygen and carbon dioxide in the lungs and, if you're unlucky, sends carbon dioxide to your brain. Apart from killing off a few brain cells, which you might miss, it can also make you feel slightly giddy — not a feeling you want at the start of an event. Start concentrating immediately.

Wind your gear up at the start. Stay out of the saddle until you're pedalling briskly, then sit down and change up immediately, moving up

through the gears until you're in the ratio you want. Now tell yourself once again to concentrate. Avoid getting out of your saddle for the rest of the race, unless it's to pull out of a tight corner or, rarer these days, away from a dead turn.

Try to develop an internal metronome. That's the clicking pendulum that musicians use to keep the right pace. Have it ticking away in your brain and match your pedalling to it. Some riders have found it useful to count repeatedly from one to seven. The system doesn't matter, but do develop some way of streaming your brain directly on the job.

A mental schedule helps. Divide the distance into stretches of around 5 miles, measured by landmarks along the route. Think of a '25', for example, as a succession of 5-mile pursuits. You can cope with it more easily. There are no decent slate-flat courses – those in the Fens are invariably windy – but even with gentle undulations, your 5-mile times should be close to identical if your training's been correct.

You can, in fact, ride it like a pursuit, but only when you're in the better half of the field. If all you rank is a '9' spot, because you're one of the 12 slowest riders, it'll be the others pursuing you and not the other way round. Either way, never look back over your shoulder. For one thing it achieves absolutely nothing. If you're riding at full pitch, you couldn't do anything about it if you looked round and saw the chariots of hell moving up on you. So why look?

Looking back breaks your concentration, it demoralises you and it encourages anyone who's having trouble catching you. In fact, if you're concentrating properly, it will never occur to you to look anywhere but up the road.

Don't change down gear unless you're close to struggling. Use your shoeplates and toestraps to pull up on the pedals as well as pressing down, doing your best to pick up the revs again. Change down only if you can't manage it.

Set your sights on your minute man and chase him determinedly. Concentrate on his back wheel. Bear down on it. Pass close by if he'll shelter you from the wind (the obligation is on the slower rider to avoid taking pace); otherwise pass wide. Go by with determination. Don't mess about.

The reverse applies if you're caught. You're in for a tough time if you're passed by the current national champion, but otherwise there's no strict reason why you shouldn't use a faster rider to stimulate your concentration and increase your speed. Step up your speed gently but positively as you become aware of your challenger and make him work hard to get by. Don't ride on his wheel or do anything which would suggest pace-taking.

Inevitably, he will move ahead. Once he's got ten yards, you can safely

concentrate on trying to re-catch him. You might not do it. You probably won't, in fact. But once you've raised your pace, concentrate on holding it. Remember that pain starts long before you approach your limit (which doesn't make the pain any less, but might make it easier to bear) and that what's hurting you will be hurting everyone else as well.

Rough roads break concentration. Ride further into the road than normal, but not dangerously or inconveniently wide. There's usually a stretch worn smoother where car wheels have begun ironing out a track. That's the bit to go for. Remember that course measurers design a '25' or whatever on the shortest distance you can reasonably ride, so keep in on left-hand curves, out on right-hand ones. Subject to traffic, take the straightest line across roundabouts. And do ride your bike in a straight line.

If you pedal at 90 revolutions a minute for an hour, you'll have completed 5,400 pedal cycles or 10,800 individual pushes. If you deviate an inch with each push, you'll have added 900 feet to a '25'. That's very roughly a fifth of a mile – and it's all quite avoidable. And the slower you pedal, the more likely you are to deviate.

It's tempting to sprint for the line when you get there. I think most people do it to convince the folk at the finish that they've put everything into their ride. What it shows, of course, is that they've done just the opposite. Time trials aren't road races – they don't have 200-metre closing gallops. Time trials finish with five miles to go. The sprint may look imperceptible from the roadside, but it's really a steady winding up of speed until you hit the line on your last drop of energy. That will gain you up to half a minute. A finishing gallop looks flashy but the difference between 200 metres at 25 mph and at 28 mph isn't worth the bother.

Streamlining

You've already seen how much effort goes into moving the bike, how much into moving the air. The proportion changes alarmingly as speed rises. Rolling resistance is almost a negligible part at time trialling speed.

There are two main sources of resistance – the spokes, and you.

I would never suggest you had 28-spoke wheels as your only set of sprints, but they're almost essential if you want to do a ride in a time trial. You can see the difference that disc wheels are supposed to make, by removing the spokes completely. If folk can ride road races on 28s, I see no reason why you shouldn't ride 25s and 50s on them, provided they're checked for tension and truth regularly. At a hundred miles and more, you

might find greater peace of mind in a pair of 36s, or a 28 front and a 36 rear.

As for you, your position has to be a trade-off between streamlining and physical comfort. Everybody can crouch low along the top tube, but not everyone can ride at 30 miles an hour (48 kmh) like that. When you find someone who *can* hold that flat-back position, it's not surprising that they've got a headstart – ask Ian Cammish.

You can use a longer reach because you're not jabbing at the bars, as you would in a road race, or tugging at them as in a track sprint. The pull is smoother, longer, like rowing. The extra stretch frees your rib cage for greater expansion.

Your pedalling action should be silky smooth right round the circle. Try to ride like a pursuiter. Keep low, with your knees well in. Wear tight clothing – it makes much more difference than any amount of aerodynamic equipment. Do a good ride on an ordinary bike and nobody will notice; do a bad one on a funny bike with disc wheels and cut-back handlebars and the world will think you're a pranny.

I used to laugh at skinsuits. I dismissed them as still more evidence that cyclists will pay anything to follow a fashion, especially when the fashion makes them look daft. Then I saw the results of some wind tunnel tests. I changed my mind. I don't understand why, but the experiments showed that long-sleeved suits were more aerodynamic than short-sleeved ones. I think that might have been a freak, unless bare skin is sticky in the wind. Probably the more important point is that long sleeves can get very hot and sticky.

The tests, which were carried out in America, showed that that peculiar rubbery material was both the best and the clammiest. It made me think of the accident a handful of servicemen had when they went running in diving suits. Do make sure there are ventilated side panels if you use a rubberised skinsuit. They might have to drain you out at the finish otherwise.

I'm by no means so convinced about so-called aerodynamic equipment. I can't see that it actually blocks any more wind than conventional equipment, so use it if you wish and provided you couldn't spend the money to better effect – on better shorts or shoes, perhaps, or even a skinsuit.

Aerodynamic equipment is generally tested in a wind tunnel, from which it emerges with splendid results. In real life, though, it's used with all the turbulence of a pedalling bike rider near it, and in crosswinds and tailwinds.

If you're inclined to doubt what I say, let me tell you the story of the golf ball.

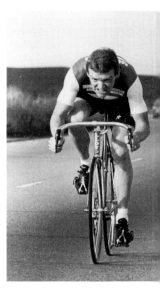

Wind resistance increases with speed, so a streamlined position is essential. Dave Lloyd of Liverpool is perfect at it.

A golf ball is much like a cyclist – it has to go a long way very fast. It's propelled by human effort and its speed depends on wind resistance. Therefore, somebody said a few years back, wouldn't it be much better to have a smooth, aerodynamic golf ball, like a billiard ball? It was silly, they said, to have a golf ball with lots of lumps and dimples that catch the wind.

Now, golf is a very old game and nobody could really remember why golf balls were dimpled. Perhaps they just looked good that way. Perhaps it was tradition. Perhaps that was just the way it was. So, one of the factories turned out boxes of smooth golf balls.

Well, you've probably guessed what happened. For all that they *should* have gone further and faster than the dimpled balls, they didn't. Back in the test room, they found that air, believe it or not, is sticky. It clings to smooth surfaces and slows them down. By contrast, when it flows over a rough surface – like a golf ball – it's deflected and loosened. And so came the end of the smooth golf ball.

Next time you think about paying twice the price for something described as aerodynamic, remember that tale.

And now back to business . . . Use the weather. Time was when everyone asked for a late start. They said it was because the air was warmer, but the usual reason was because they hoped the traffic would have built up a bit. The RTTC aren't daft, though, and they've done away with the most notorious dragstrips. The weather, though, does change during a race. It'll certainly be different for number 1 and number 120, and it can change midway through one individual's ride.

For that reason, there's no point in saving yourself into a headwind start and gambling on a float ride back from the turn. You may have got the wind direction slightly wrong. The return stretch of the road could be more sheltered by hedges or walls and deny you the help you want. And anyway, not going flat out isn't racing – it's just not-going-flat-out.

It obviously makes sense to keep extra low into a headwind. But you should keep down on the drops with a tailwind, too. It *feels* faster with a tailwind because you don't get the same rushing noise in your ears. It's obviously faster than it is into the headwind. But – and this is a strictly mathematical rule – the wind has to be blowing faster than you can ride to be worth sitting up a bit.

In other words, if the fastest you can pedal even with a tailwind is 40 mph (65 kmh), it has to be a 41 mph tailwind before it will push you along. And you'd never have started in a 41 mph wind. Anything less than your maximum tailwind speed simply lessens the air resistance; it doesn't remove it. So it'll always pay you to stay in a streamlined position.

Crosswinds are troublesome mainly because they're intermittent. You can usually treat them like a headwind, because the chances of a 90-degree

breeze are pretty remote. Most crosswinds are just angled headwinds. The difference is that you can exploit hedges, trees, fences, even spectators and passing traffic.

Tilt your head slightly to one side and you'll be able to stay lower without making your neck ache. Never stop looking ahead; time trialling is like driving on a motorway – generally safer but the accidents are worse. More riders in Britain are killed in time trials than in road races, usually from piling into the back of something.

Equipment

Time trial bikes get less hammering than anything except a pursuit machine, and even that's an arguable statement. Certainly they don't get sprinted on, braked hard, ridden over cobbles or stamped away from the start. It means almost everything can be lighter, right down to the wheels and the frame.

But what else you can discard depends on how far you're racing. A hundred miles is a long way by anybody's standards: 12 or 24 hours are very much further. So, depending on what you're riding, consider this:

— Use a single chainset with four or fewer gears; you might need only three in a '10' or even a '25', and fewer sprockets save weight
— Adjust your chain so that it hangs slightly limp – fractionally longer than usual; it won't be bounced about as much as in a road race and the slackness will take the tension off the jockey wheels
— Tape your handlebars only on the bottoms and remove the brake hoods
— Take one ball out of each hub bearing and use light oil in place of the grease
— Do away with pump, pump pegs and spare tyre if someone will come and get you during a short race
— Abandon the bottle cage and bottle.

Similarly, you can ride much lighter wheels. The best rims, needless to say, are the ones that for some time have been difficult to get – the V-section ones with the internal spoke nipples. They make a very strong and light wheel with fewer spokes. They're also rather more expensive.

If you want to be a *real* roadside baron, tell everyone you've got helium in your tyres. If you really had, it's said it would save you 10 grams a tyre, although I don't understand the arithmetic.

The rule for tyres is simply to use the lightest you think you can get away with. It depends on the course, on your weight, and the size of your

wallet. And how much you're prepared to gamble. Probably 200 gm is a good weight for most people.

It's tempting to use longer cranks – 172·5 or 175 mm – but remember that the longer push also means a higher leg at the top of the cycle. That means greater top-dead-centre problems if your legs aren't quite long enough. There are other considerations as well. You can only use longer cranks effectively on a course without a lot of corners. Apart from the fact that you're forced to freewheel where you might otherwise have pedalled, there's also the fact that longer cranks are more tiring when you're repeatedly having to pull away out of corners. If you think that's daft, given the physics of levers, it's because the benefits of the longer cranks are overcome during acceleration by the extra movements that the muscles are having to make. Long cranks are ace for rolling, not so good for accelerating.

On the other hand, another 2·5 mm on your cranks can be worth another tooth on your chainring. You pedal more slowly for the same output, because your feet have got further to go. But you can pull round more chain.

Schedules

How you ride a time trial depends on your skill and your stamina. Your stamina depends on your speed. Look at it this way: your initial improvement, and some of your general improvement through the season, will come from better pace judging; in other words, from improved skill. Some, too, will come from warmer weather. When that skill improvement decreases, your times will improve less and, if your training's not progressive, will level off.

At this point, it's important to know where you're losing time. In a '100', for example, it's theoretically possible to ride each 25-mile sector in the same time: 4 x 1:00, for example. In practice, though, you may actually be riding the first 25 in 58 minutes, the second in 59, the third in 1:1 and the last in 1:2. Or, less usually, you may ride faster towards the end than at the beginning. Now a little analysis becomes necessary.

If all other things are equal – the road surface, the wind and everything else – slowing towards the end shows weakening recovery powers. A slow start suggests a poor warm-up (a warm-up's more important for a time trialist than for a roadman), an inability to concentrate early in the race, or poor pace judging which makes you scared to go too hard in the opening miles.

You can work on all these things. And when you do, remember that in

the end it's speed that increases stamina, because increased speed demands increased endurance, which demands faster recovery. So don't run into the classic mistake of riding ever-longer but slower training miles because you fade at the end of races. You fade because you're not riding fast enough in training; you know you can ride 100 miles, so distance isn't the problem.

In a real world, of course, it's impossible to balance your ride exactly. You'll soon see where the consistent variations come. And now, if you want to write a long-distance schedule, you base your timings on your experience.

Schedules are less popular than they were. It was once quite common for riders to start a race with a note of intermediate timings stuck to their stems. For some it's a source of encouragement; for others, like a handlebar watch, a distraction. Only you can decide which. It's purely subjective because cold-hearted folk say that you should be riding to your cruising limit anyway and that no schedule or ticking watch should make an ounce of difference. On the other hand, there's not a rider alive who couldn't pull out something remarkable if he was within a minute of competition record with half a mile to go.

Once you get beyond 100 miles, of course, some sort of schedule becomes essential. 200 miles is a very long way and 507, the record for 24 hours, is more than most folk would consider. You can't organise your helpers – and it's not practical to ride a '12', let alone a '24,' without help – unless you have a pretty clear idea where you plan to be and when.

There is no point in drawing up a schedule for anything but your personal best time or, failing that, the best time you would accept in your state of fitness. The reason is utterly simple: why plan to ride five minutes slower than you could?

Your helpers in a '12' or '24', apart from the mundane tasks of supplying you with food, drink, lights and warm clothes, should also be quite capable of calculating your eventual distance at any stage of the race. It is they who should have the schedule in detail; it's you that should concentrate on it.

9 All together now

There are too few team time trials in Britain to make it any more than a knockabout activity. Well, that's true enough. But there aren't any more anywhere else, either, so how come they always do so well at it while we end up way down the list?

Well, the answer is that the emphasis is more on team than on time trial. You do have to ride as fast as you can against the clock, naturally, but in a very different way from the individual event. Other countries are more prepared to coach riders specifically for the event, particularly in East Germany and the Soviet Union. They also have less confusion over what the event actually is.

We have this solid time trialling background which sees the TTT as an extension of the individual event. They don't. They start from the premise that it's really a component part of a road race. Therefore, since they don't have specialist time trialists, they use roadmen.

There are two main differences. The first is that the skill of precision riding is very high. The second is that individual time trialling is entirely aerobic – you don't go into oxygen debt by using more oxygen than you can breathe in – whereas team time trialling is intensively anaerobic every time you hit the front. That means you spend the maximum period of about 12 seconds riding at the front on the body's chemical rather than oxygen processes, and for the rest of the race on your recovery mechanism. You have to be as near as you can to aerobic by the time you hit the front again because, it you aren't, you'll ride slower than you did before.

More than that, the lactic acid that makes your muscles painful will just get higher and higher before a nervous reaction forces you to slow down or start missing turns at the front.

Recovery depends, apart from on your fitness, on the shelter you get from the back wheels. A good team, therefore:

— Can ride extremely close together
— Is much the same height and shape
— Has tremendous recovery powers
— Has a high toleration of pain
— Can ride high gears with a uniform pedal action
— Has a firm plan on which rider should sacrifice himself or be dropped.

You don't get all that by picking the only three or four available clubmates for an event three weeks hence. Nor do you get it, without a lot of direction and tears, in a couple of months. A team that plans to ride well in a team time trial has to establish a riding order – usually in ascending height order, or tall-short-tall-short, a starting order (will the event start championship style, straight across the road, or will the lead-out man start at the back to let the others latch on?) and above all an esprit that comes only from continual training together.

The longer, flatter and smoother the course, the more it will suit big riders. The rougher, hillier and twistier, the more it will favour lighter, more agile roadmen.

The spell at the front should be as long as can be sustained anaerobic-ally. Generally it'll work out at about twenty pedal revolutions on the flat, but you can vary that slightly to suit you all. It'll drive you barmy, counting pedal revs for 62 miles. It does have to be a standard period for everyone, though, calculated on the length that the weakest member can manage for the first half of the race. He'll be the one to drop after half-distance, anyway. After that, you set the pace and the time at the front on what the third-strongest rider can manage, letting an extra-strong rider spend a few extra seconds on the front. Just a *few* seconds though – not an extra half minute. Only experience and repeated riding together will teach you.

There are only four of you, more usually three, so the double line of a road race break is impractical. It's usually better to reduce the lead time into a headwind rather than adopt a double line. It is possible to fan across into a gentle echelon for crosswinds, though.

Change with a clean, decisive action. Pull across with no room for misunderstanding. Keep pedalling but don't slow down until the second man is right alongside you. Then ease fractionally and let the others come by you as close as you can. Change down by one sprocket to make your recovery faster.

The usual mistake is to swing off the front and ease immediately. But think a while. Every time you move over and slow down abruptly, you have transferred the front of your group from the leading edge of *your* bike to the leading edge of the bike behind. That's about 5½ feet (1·7 m). If

you change every 200 metres for 100 kilometres, you lose 5½ feet no fewer than 500 times, which is 2,750 feet, or rather more than half a mile. At 30 mph, that's a minute.

Instead of easing up, keep going. Make them fight their way through. You'll get slower anyway, and however hard he fights it, the second man will always accelerate a little.

Once you get to the back, swing neatly on to the back wheel and follow it wherever it goes. It's a bit like riding on a flexible tandem – the guy in the front decides the line you'll ride and the rest of you follow. You can't all steer and stay in a straight line. Change back up a gear when you get to second place, ready to take your turn at the front. Be sure you've arranged this gearing technique with the others, though, because your formation should be so tight that unexpected changes could cause consternation and waste of energy.

Classy times for a 100 km TTT			
km	48 kmh	49 kmh	50 kmh
5	6:15	6:08	6:00
10	12:30	12:15	12:00
15	18:45	18:22	18:00
20	25:00	24:30	24:00
25	31:15	30:37	30:00
30	37:30	36:45	36:00
35	43:45	42:52	42:00
40	50:00	49:00	48:00
45	56:15	55:07	54:00
50	1:02:30	1:01:15	1:00:00
55	1:08:45	1:07:22	1:06:00
60	1:15:00	1:13:30	1:12:00
65	1:21:15	1:19:37	1:18:00
70	1:27:30	1:25:45	1:24:00
75	1:33:45	1:31:52	1:30:00
80	1:40:00	1:38:00	1:36:00
85	1:46:15	1:44:07	1:42:00
90	1:52:30	1:50:15	1:48:00
95	1:58:45	1:56:22	1:54:00
100	2:05:00	2:02:30	2:00:00

The first three riders count in a four-man time trial; with a three-man, it may be the whole team that has to finish or just two riders. Either way, don't wait for someone who gets dropped unless you've got a long way to go. It's not quite the same as a large road race break, where you can afford to nurse somebody. Speed is absolute in a TTT and a dying rider will hinder rather than help.

The only time the line should separate is before corners. You can always get round a corner faster by yourself than in a group, so separate by a couple of feet, take the bend as fast as you can, and re-group as you accelerate again. Change the lead immediately you've accelerated.

Take all hills at full speed. Don't change immediately before the summit. Go over the top fast and then change. Keep on accelerating downhill.

Your emphasis should be on pedalling routine rather than speed. If that sounds crazy, think of it this way: smooth, fast pedalling is more productive in a tight group than repeated stabs of speed which increase oxygen debt for those who should be recovering. So, if the going gets either hard or very, very fast (down a hill, for example) take shorter turns and concentrate on maintaining your pedalling speed. Road speed will follow that automatically.

Of course, there's much more chance of getting a two-man or even a three-man team than there is a four-up. Four-man time trials are the *crème de la crème*, but they're not exactly thick on the ground. Most years there are just two, both of them (ludicrously) championships.

There are enough three-man events around each year, though, to make it worth while training for a couple. The speed is lower than a four-man, and it's easier to get a team together. Don't neglect the chance.

Two-man time trials are much more ad hoc affairs, without a great deal of kudos. They're also more likely to be on non-standard courses, with a few hills, which means they suit smaller, livelier riders and not the great hunks you see riding championship four-ups.

Two, three or four-man, though, get your best man on the front as you pass another team. The slipstream effect is much greater than in an individual time trial. So is the ability to respond. Wind up the speed to two or three miles an hour faster than the slower team. Blast by as wide as you can. Get your fast man off the front once you've got by and let him have a short lead next time so that he can recover. It's up to you, then, to keep the pace up. Let the tough guy do one more rocket blast and then settle down to your original speed. It's tough, but anything else will give the other blokes an incentive to keep up with you, a battle which could last for miles and tear you to bits.

Try not to talk during a race. By all means yell if somebody goes through too hard or if you puncture. But otherwise keep breathing hard, keep concentrating. Use pre-arranged elbow movements to show when you're about to pull over. Use shorter turns to show if you're suffering badly. Use your front wheel to steer everyone round the bumps and potholes. Don't shout about them.

10 On the track

It's curious, in a country which has only three decent outdoor tracks — Leicester, Meadowbank and Harlow — and no accessible indoor ones that we should have done so well at track racing over the years. Odder still that much of that success should come when at least one of those tracks didn't exist and the other two, if they were there at all, were in a rougher state than today.

Reg Harris was world sprint champion four times between 1949 and 1954, Norman Sheil was amateur pursuit champion in 1955 and 1958, Beryl Burton was the top woman pursuiter five times between 1959 and 1966, and Hugh Porter won four world pursuit titles between 1968 and 1973. Then, of course, came Besançon and the latest British champion, Tony Doyle.

Pursuit

Start with your front wheel on the line, halfway between the datum and sprinters' line. Tilt the bike slightly down the track to take advantage of the slight banking in the straights or (in a four-station pursuit) the greater banking in the bends.

The fastest acceleration comes from a crank position just a little more shallow than parallel with your down tube. It doesn't matter a very great deal which foot you start on, except that the track is higher on the right. If you start with your left leg, therefore, so that the bike tilts that way, there's less chance of clipping the banking.

Getting the start right is very important. The reason for having the crank nearer to the horizontal than normal is that you're further from top dead centre and the bike will move forward more quickly. The obverse of

this is the novice's problem of putting pressure on the back pedal as well as he lifts himself out of the saddle; sometimes enough pressure to move the bike fractionally backwards rather than forwards. Relax your lower leg as you anticipate the start shot. If you can see the starter comfortably, go on the puff of smoke from the gun and not on the pistol shot. Tell your pusher exactly what you want, overwise you may start by towing his hand with you.

Professionals ride 5,000 metres, amateurs 4,000 and women and juniors 3,000. Times run to about six minutes, five minutes and four minutes respectively. Don't go straight to your fastest speed. Any of those distances is quite a long way. You should get to your best cruising speed by 450 metres and hold it absolutely even all the way through.

In practice, this is almost impossible to do, not least because the first part of the race is from a standstill. That means your opening lap on a 333-metre track like Leicester will be three seconds slower than the rest. Cutting those three seconds will give you an initially higher average but it might also mean going into oxygen debt too early. The idea is to get to your cruising speed as quickly as you can, hold it evenly to the end and complete the distance with total oxygen debt. That way, as in a good time trial (which is what a pursuit is, of course), you finish along with your last drop of energy.

There are risks to starting slower and finishing faster, as Hugh Porter found out. His constant acceleration gave him an average that proved unbeatable on several occasions and won him world championships. But it also lost him one. Until the quarter-finals, pursuits are ridden for qualifying times only. After that, the race stops when one rider catches the other and the slower man is eliminated.

This is quite a risk for a slow starter on a small track, where there's less distance to make up. The little Belgian Dirk Baert worked that out, decided he couldn't win if he let Porter go the distance, and rode the opening laps at a speed he could never have sustained. By effectively riding a 3,000 metre pursuit against Porter's 5,000, he caught him before the end.

It's important, then, to know your split times all through a pursuit and, most importantly, while you're racing in preparation for an important event. Only then can you adjust your riding – a slower start, a faster start, whatever – to improve the average.

Once you know your target times, there are two things to watch. The first is the lap lights, which will flash on and show who's actually ahead. Never gawp across the track to see for yourself. The second is the position of your coach or helper. A good coach can transmit a lot of information to you as you ride, without saying a word. By standing before or after the

finish line, he can indicate how much up or down you are on your opponent. By crouching, stooping or standing, or using hand and arm positions, he can indicate where you are on your own schedule. With his fingers he can indicate the number of laps still to go. And if all else fails, he can shout at you.

Times for a 4 km pursuit on a 333 m track					
Lap					
1	28·62	28·24	27·75	27·37	26·99
Differential	3·4	3·8	3·0	3·4	3·8
2	25·58	25·16	24·75	24·33	23·91
	54·20	53·40	52·50	51·70	50·90
3	25·58	25·16	24·75	24·33	23·91
	1:19·78	1:18·56	1:17·25	1:16·03	1:14·81
4	25·58	25·16	24·75	24·33	23·91
	1:45·36	1:43·72	1:42·00	1:40·36	1:38·72
5	25·58	25·16	24·75	24·33	23·91
	2:10·94	2:08·88	2:06·75	2:04·69	2:02·63
6	25·58	25·16	24·75	24·33	23·91
	2:36·52	2:34·04	2:31·50	2:29·02	2:26·54
7	25·58	25·16	24·75	24·33	23·91
	3:02·10	2:59·20	2:56·25	2:53·25	2:50·45
8	25·58	25·16	24·75	24·33	23·91
	3:27·68	3:24·36	3:21·00	3:17·68	3:14·36
9	25·58	25·16	24·75	24·33	23·91
	3:53·26	3:49·52	3:45·75	3:42·01	3:38·27
10	25·58	25·16	24·75	24·33	23·91
	4:18·84	4:14·68	4:10·50	4:06·34	4:02·18
11	25·58	25·16	24·75	24·33	23·91
	4:44·42	4:39·84	4:35·25	4:30·67	4:26·09
12	25·28	25·16	24·75	24·33	23·91
	5:10·00	5:05·00	5:00·00	4:55·00	4:50·00

You'll need a calculator to work out a schedule if the event's not over complete laps. The formula is this:

— Calculate the target time in seconds and deduct three seconds for acceleration

- Divide that figure into the distance in metres
- Divide that figure into the 'odd' distance
- And the answer is the time in seconds to cover that distance
- Finally, add the three seconds you deducted for acceleration.

Times for a 3 km pursuit on a 333 m track					
Lap					
1	29·36	28·96	28·48	28·00	27·60
Differential	3·03	3·08	3·04	3·00	3·05
2	26·33	25·88	25·44	25·00	24·55
	55·69	54·84	53·92	53·00	52·15
3	26·33	25·88	25·44	25·00	24·55
	1:22·02	1:20·72	1:19·36	1:18·00	1:16·70
4	26·33	25·88	25·44	25·00	24·55
	1:48·35	1:46·60	1:44·80	1:43·00	1:41·25
5	26·33	25·88	25·44	25·00	24·55
	2:14·68	2:12·48	2:10·24	2:08·00	2:05·80
6	26·33	25·88	25·44	25·00	24·55
	2:41·01	2:38·36	2:35·68	2:33·00	2:30·35
7	26·33	25·88	25·44	25·00	24·55
	3:07·34	3:04·24	3:01·12	2:58·00	2:54·90
8	26·33	25·88	25·44	25·00	24·55
	3:33·67	3:30·12	3:26·56	3:23·00	3:19·45
9	26·33	25·88	25·44	25·00	24·55
	4:00·00	3:56·00	3:52·00	3:48·00	3:44·00

(Tables: *Agonistic Cycling* by Agostino Massagrande)

Usually, in fact, you'll ride faster on the first and second quarters, slower on the third, and then slightly faster on the fourth as you press for the line. There's nothing badly wrong if the variation's not marked. But a poor third quarter suggests too fast a start, and a steady decrease of speed all through shows too fast a start combined with poor fitness. Only specialists maintain an even pace throughout, but it's nevertheless the target to go for.

The first events in a pursuit series are elimination rides. They're rarely necessary in Britain because of the hard times that track racing's going through. Even so, if they happen, the idea is to decide who will get to the quarter finals, or, occasionally, to the last 16.

The faster you ride, the more likely you are to get through to the race proper and the easier the run of opponents that you'll get. That's because the fastest are matched against the slowest qualifiers. If you *know* you're in with a good chance of a medal, and if there are two or three main contenders and a lot of also-rans, you can afford to relax a little in the heats and ride for a good but not remarkable time. If, on the other hand, you're an outsider, you've got to produce a good ride just to stake a claim.

Gearing's important because you need a ratio that you can keep going at the same speed into the wind. It works out better to maintain an even rhythm, using your hamstrings and shoeplates more into the wind. You'll lose your rhythm if you struggle into the wind and fly with it behind you, and the two sums never balance; you always go slower.

Big chainrings roll more smoothly than small ones, so aim for 50 or 51 on the front and a 15 on the back. That's a general rule for a senior. If you have to vary your gear, consider the options. You could vary the size and keep the revs or change the revs and keep the gear size the same. The formulas are:

$$\text{Revs per minute} = \frac{\text{distance in km} \times 12{,}531}{\text{gear in inches} \times \text{time in minutes*}}$$

$$\text{Time in minutes} = \frac{\text{distance in km} \times 12{,}531}{\text{revs per minute} \times \text{gear in inches}}$$

$$\text{Gear in inches} = \frac{\text{distance in km} \times 12{,}531}{\text{revs per minute} \times \text{time in minutes*}}$$

(*Remember to express the seconds in decimals so 5 m 30 secs becomes 5·5, 5 m 20 secs becomes 5·33, and so on. The same applies to the other equations.)

Gear developments

83·1 = 40 × 13	86·7 = 45 × 14	90·0 = 40 × 12
84·4 = 50 × 16	87·2 = 42 × 13	90·6 = 47 × 14
84·6 = 47 × 15	87·8 = 52 × 16	91·1 = 54 × 16
84·9 = 44 × 14	88·2 = 49 × 15	91·4 = 44 × 15
85·7 = 54 × 17	88·7 = 46 × 14	92·6 = 48 × 14
86·4 = 48 × 15	90·0 = 50 × 15	93·4 = 45 × 13

It's an obvious statement, I suppose, but it's worth saying: tracks are measured around the bottom line – the datum line. Every inch you ride above that line can add feet and eventually yards to the length of the event. Every inch you go below it will save you a foot or two – but it's also against the rules and you risk disqualification.

Use a $\frac{3}{32}$-inch chain and tight clothing; wind resistance is important. The bike has much the same outline as a roadman's, with a shorter fork rake and lighter tyres. The saddle and bar position are identical, though; you can't go to the extremes of sprinters or kilometre riders because the distance is too great and you need full use of your diaphragm.

Team pursuit

The team pursuit is to the individual like the team time trial is to the solo event – a lot more skilful, a lot more demanding and very much faster. World-class times are about 20 seconds faster. That's for men. Nobody knows what women would achieve because, for some reason, there's no women's event.

Individual pursuiters aren't necessarily good candidates for the team event, though. It tends to favour road and madison riders and, sometimes, good kilometre time trialists. There's not much scope for different sizes of rider (although we've won medals with Ian Hallam in the team, and there weren't many around of his height) and it helps if you're all on exactly the same gear – say 51 x 15, pedalling fast.

The start position is the same as for an individual ride, with the first bike on the bottom pointing slightly downwards, the other riders directly up the track away from him. It's not always best to have the fastest starter as your first man – you need somebody strong, naturally, because the start takes a lot out of you. But all you'll do by putting a jack-rabbit on the front is rip the line apart before it gets together. Put him second, by all means, and he can wind the line up to its maximum speed.

Equally, don't put your slowest starter in the middle of the line. He'll just break it up. Start him at the back. That means he'll start up the track a bit and the slope will get him off his mark.

A lot depends now on your skill. And skill depends solely on practice. You have to get the team together immediately, accelerating throughout. You then, of course, have to keep it together, riding close but not immediately on the datum line.

You can't ride as close to the track limit as you'd choose to for an individual pursuit, simply because there are four of you and you need just that little bit more room. There are small sandbags or other markers on

the line in championship events and the last thing you want is to leave so little room for a little wobble that you all come crashing down in the last bend.

It's all very well for you to swing round the bottom of the track, stylishly going for glory as you lead the string of superbly-pedalling athletes, but the poor bloke in third or fourth spot is having a much harder time because he can't see half as much of where he's going. Do, then, as you would be done by . . .

Once you've got started, you've then got to worry about the changes. The only place you can change, really, is the banking. I suppose you could try in the straight, but you'd be daft because the bloke getting to the back would arrive just as he starts to climb the banking. He then gets shot off, which isn't the idea at all.

So change on the bankings, every lap on small tracks (up to 250 m, for example) and every half-lap on tracks like Leicester, where the championship is usually held. Leicester is only 333 m and you may think you can hold the extra distance and do so without losing the bike length that disappears every time you change. But you won't do it. It's much better to change within the maximum anaerobic distance − 12 to 15 seconds, remember − than to ride slower or to blow up by going beyond it and not

Keep close together and close to the line in a team pursuit.

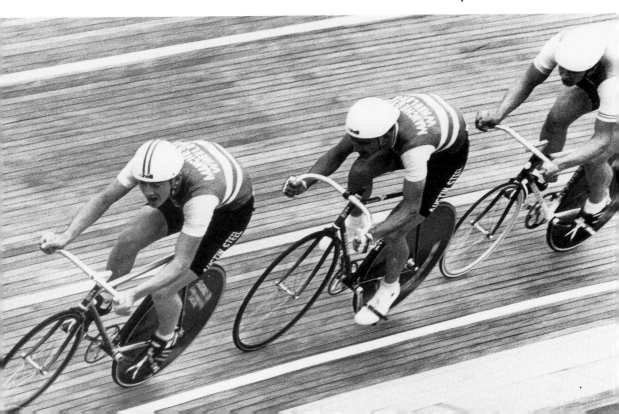

recovering. You may feel a hero but the others will be banging up against your back wheel.

Without violent accelerations, the end of your stint should be fractionally faster than the start.

The variation you have got in half-lap changing, though, is that you can use the point of swinging up as a signal. Swing a few yards early and you're suffering; swing late and you're feeling strong. This could have some bearing on whether you take three or four men to the finish.

You normally change going into the banking by swinging up hard, going up close to the fencing on a steep track and coming down hard on the third man's wheel. However hard you try, there'll always be an acceleration when the lead changes, so the exaggerated use of the banking lets the relieved rider get back on. A shallow or bumpy track won't do that for you, though, so don't go more than halfway up or you'll have to sprint your way back on.

It stands to reason, obviously, that you have to ride on a wheel rather than overlapped. You can't go below because of the datum markers; you certainly can't go above because the front man will take your wheel away when he swings up.

Generally the favoured routine is to have a fast-start man who'll drop off with a lap (or occasionally two laps) to go. He's done his job and there's no point in hanging on and slowing everybody down. Make sure, when you do your calculations, that he's going to be on the back when his time comes. If he's in second or third place you've messed it all up.

By the way, whenever anyone drops out, whether it's scheduled or not, it's important to tell the others. Shout 'going' or whatever will make sense to you all. The time to find out that there are only three of you left isn't when you're at the top of the banking waiting to swoop down on the line. Nor, if you thought *you* were the guy to drop out, do you want to find that someone else has already done so.

Similarly, you need your stronger riders to take the stretches into the wind, and an iron man on the front for the last lap, the man who'll tow you all at frightening speed to the line. It's then the second rider's job to try to lead man number three (on whom the clock is running) past number one in the last hundred yards. But don't do it too early or you'll hit the wind and slow down.

The best way of doing this is for the leader to move gradually up the track on the last straight. His time isn't important, so the fractionally extra distance doesn't matter. It does, though, let the other two through on the inside, on the shorter route.

Team pursuits are frighteningly fast. You can't do well locally, let alone nationally or internationally, without a lot of work together. Straightfor-

ward speed is important, of course, but the changes are particularly important. So are the individual lap (or half-lap) times and the team order.

Split times for 333 m tracks

Acceleration	5·08	5·04	5·00	5·08
Lap 1	26·74	27·12	27·50	27·99
Lap 2	21·66	22·08	22·50	22·91
	48·40	49·20	50·00	50·90
Lap 3	21·66	22·08	22·50	22·91
	1:10·06	1:11·28	1:12·50	1:13·81
Lap 4	21·66	22·08	22·50	22·91
	1:31·72	1:33·36	1:35·00	1:36·72
Lap 5	21·66	22·08	22·50	22·91
	1:53·38	1:55·44	1:57·50	1:59·63
Lap 6	21·66	22·08	22·50	22·91
	2:15·04	2:17·52	2:22·00	2:22·54
Lap 7	21·66	22·08	22·50	22·91
	2:36·70	2:39·60	2:42·50	2:45·45
Lap 8	21·66	22·08	22·50	22·91
	2:58·36	3:01·68	3:05·00	3:08·36
Lap 9	21·66	22·08	22·50	22·91
	3:20·02	3:23·76	3:27·50	3:31·27
Lap 10	21·66	22·08	22·50	22·91
	3:41·68	3:45·84	3:50·00	3:54·18
Lap 11	21·66	22·08	22·50	22·91
	4:03·34	4:07·92	4:12·50	4:17·09
Lap 12	21·66	22·08	22·50	22·91
	4:25·00	4:30·00	4:35·00	4:40·00

(*Agonistic Cycling* by Agostino Massagrande)

You can't train for a team pursuit without a sympathetic coach who's got a nifty way with a stopwatch. You have to try every combination of order, timing, timing, timing all the time to see what effect the changes have. It's not even the case that the weakest rider has to lose his place, because a replacement might be *too* strong or be a poor starter or finisher.

You also have to have several plans, all of them workable. What you got

to work on Reading track isn't going to be worth a thing at Leicester or Meadowbank, or vice versa. You *have* to train on a track as similar as possible to the one on which you want to be a star. You have to know what to do if the wind picks up or changes direction. You have to have a fifth rider as a reserve who's ridden with the team all along.

Otherwise you're just in it for a few laughs and a very miserable five minutes.

11 Still going round the bend

Sprinters are weird blokes who look like stumpy body-builders and behave like prima-donnas. Discuss.

Actually, some sprinters are fairly normal people. It's just that, of all events, it suits tense, shortish riders with more than the usual amount of bulk. It's all power and tactics.

Nothing about a sprint makes sense to strangers. It's over a kilometre, but the timing's only over the last 200 metres. You may stop, which outsiders find unbelievable, and there's actually a rule against reversing. Is this cycling?

Everything about a sprint follows that same old rule about wind resistance increasing disproportionately with speed. The parallel of this is that you'll get more shelter the faster your windbreak moves.

Sprints are run as three-ride elimination heats and final. Championship matches are always for two riders, which makes the tactics purer, but you might occasionally get three or even four, particularly in heats. Let's think for the moment about two-man sprints, though.

There must have been a time when nobody was specified as lead-out. Then one day the race must have started and both riders stopped, balanced, on the line. There's an advantage to being at the back because you can take pace when you choose to, and you can see without being seen. So the rules were changed. Now there's a draw to see who must lead away from the start and the second rider doesn't have to come by in the first lap if he doesn't want to. That means the leader can't stop and balance in that time.

Between then and the line, as Tim Mountford described it, 'match sprinting is a rolling chess game which features balancing, feinting and explosive sprints. Split-second decisions made in the heat of competition will ultimately spell victory or defeat, making the match sprint a contest of nerves as well as physical skill.'

And as another American, Roger Young, added: 'It takes a lot of thought, too. You have to compute everything. You have to know the track surface and conditions, the wind and where it's coming from, what your opponent is good and bad at, and what you're good and bad at. You make your plans from that.'

The plans come down to whether you want to lead or your opponent does. As I've said, usually neither of you does.

Let's assume for a moment that the draw had you leading out. You've got to get your man past you. You can bluff or you can prove yourself a better bike rider.

Move steadily up the track on a moderate angle of banking. Watch carefully for any suggestion of your opponent sweeping back down and going for a long sprint. This is most likely to happen where there's a tailwind finish, which would force you to chase into a headwind and deny you the best effects of slipstreaming in the home straight.

If he's still there, stop as hard as you can. Rub your track mitt on the tyre if necessary. The sharper you stop, the greater the chance he'll carry on by or at least come level. Turn your bike at about twenty degrees down the track and steer to the right. Keep your cranks just a little shallower than the down tube and move your weight from pedal to pedal. Tell yourself you're prepared to stay there for hours if need be. In the old days, sprinters could be locked like that for ages and the crowd would gasp at the slightest sign of anyone cracking.

Now, in more philistine days, they're more likely to watch for a while and then go off for a cup of tea, but take no notice. It's your ride, not theirs. The nervous strain is now on the guy at the back because you've taken control; he has to anticipate and out-stay you. He'll be more aware of any crowd noise than you are.

The judges will be watching you both. You can move the bike fractionally backwards, but only enough to maintain your balance. You can't adjust your pedal angle enough to make them think you're reversing. Keep watching your opponent.

This is an essential skill for any sprinter, so practise whenever you can. The former junior sprint champion, Neil Dykes, who lived miles from any track, was once pictured in his local paper practising track stands on the angled supports of a flyover bridge.

One or other of you will have to break. Either way, you'll go down the banking. If it's you, try descending sharply to the sprinters' line and turning sharply back up the track. That'll slow you down suddenly and there's no room beneath you so your opponent will have to turn short and come over the top of you. The alternative is to end up on the grass.

Don't do this too late in the race, though, because all the time you're

down the slope and stopping, he's up the slope and accelerating. You've got to take him down sharply enough that he's got to stop harder than you did, at the same time giving yourself scope to jump on the flat.

An alternative is to feint a standstill by skimming your hand on the tyre and shuffling your body, but without kicking back. If you're quick and convincing, you can get him to slow hard while you're putting your hands back on the bars and going like fury.

If neither of these works, try going straight back up the banking. You don't have room for more than two tactics, so be prepared for him now to come by fast on the inside. You can then use the banking to respond. With luck he'll just follow you up. The more you can get him alongside you, the more you can turn and sprint back down while he's still going up.

A variation of this favours heavier, stronger riders. A handful have this ability to turn right in the middle of the banking, climbing like a roadman. It forces the opponent to follow or pass. (The other side of this is that lighter riders can go more slowly on the bankings without sliding down – a point worth exploiting unless you've got the heavier bloke above you, in which case he'll take you down as well.)

If you go too far up the banking, though, without getting him inside you, you give him the option of holding you against the fencing. By getting his bars across yours, he can hold you there for as long as he chooses, unless you can physically push your way down. Pushing changes your centre of balance, though, and gives him a chance to jump.

The other classic box is to take a rider down to the bottom of the track and invite him to come through on the inside. You then box him below the sprinters' line (the middle of three parallel lines round the track), from where the rules say he can't pass on the inside.

If he comes by on the outside, sprint hard with him but move up the banking as you go. He always has to ride the longer line, which may be much further than he'd choose, and you can angle yourself out of the final banking so that you get a more decisive descent than he does.

You'll have realised by now that longer tracks help the second man. The bankings are shallower. And, therefore, you're at less disadvantage at the front on a short one.

From the back, you're obviously prepared for all the tactics that the other bloke might throw at you. Remember all the time that he has to have the more extreme tactics. For fractions of a second he has to have his pedals in the wrong place, has to be pointing the wrong way, has to lose concentration. He's at a disadvantage, but he can do a lot to get out of it. And he will if you let him. And then, because he's in front, he'll possibly beat you. So take your chances when they come.

Keep the race rolling if you've got the weaker jump. That lessens his

advantage. Go early if he's the better sprinter (and especially if there's a tailwind finish) and keep accelerating all the time. It's hard to outjump a lead-out man who keeps getting faster. And on some tracks it's almost impossible to get by on the last banking, a fact which will suit you on a small track.

Let the other guy lead if you've got a headwind finish. He might be willing if he knows he's stronger than you, anyway. A small track means he'll kick off with the wind and then hit the air. Momentarily, he'll slow down. Go.

If you lead, there's nothing to stop him waiting until you pop and then coming by. If *he* leads, you might be able to control things. Remember that the jump will probably come late.

Watch even at this stage for bluff. Reg Harris, the only great sprinter we've ever had, was famous for what he called his lullaby technique. By appearing to sprint flat out, he could bluff his opponent to give it all the stick he had and come off his wheel. He'd then put in the last killer kick.

His coolness also let him trick the best in the world. He won one world championship simply by moving up the track in the last hundred metres. His rival, forced to go wide or come by below, chose to come by below. Harris moved back down and trapped him on the sprinters' line.

To paraphrase Kipling, if you can think when all about is pounding blood and aching lungs, then you are a man, my son.

Track bikes break all the usual rules. They're not machines you'd go touring on. The handlebars are deep and set close in for streamlining and maximum pull; the frame is steep; the tyres are uncommonly light. These are bikes designed for 12-second efforts, not for protracted riding.

Use a heavier grade of tubing. Any whip in the frame is lost acceleration.

The deadweight is entirely unimportant. The frame should be more upright than usual to bring you up over the pedals. The bars should be lower, for streamlining, and slightly closer in to give you a better upwards pull. Some riders still prefer steel stems and bars, but I fancy alloy is plenty strong enough these days.

Similarly, you'll need 36-spoke wheels, possibly even tied and soldered if you're fairly heavy. Remember that the soldering needs checking frequently because it can dry out and become brittle. Then all that happens is that the spoke flexes as usual, sliding up and down inside the solder.

By contrast, you can use featherweight tyres. You're hardly riding them any distance. Punctures can happen but they're hardly commonplace. The lighter the tub and the harder it's pumped, the more zap you've got from

your kick. Try around 150 gm if you can afford them, pumped to 140 psi. They should most certainly ping when you flick them with your finger.

You have a fairly free range with gearing, moving up as the season progresses and the tracks change. You might start in 46 × 14 and get to 48 × 14 for something important. Again, small chainrings and short cranks improve acceleration. Since all that matters is the strength of your jump and whether you win races, the gear that suits you is the one to use.

Times vary from track to track and competition to competition. You'd be doing fairly well at 11–12 seconds for a fella and about 12·5 for a woman.

The maddest sprinters of all ride tandems. Sadly, there are too few races each year to make a speciality of them, although there have been notable pairings. The two Frenchmen, Daniel Morelon and Pierre Trentin, clocked 9·83 seconds for the last 200 metres of the Olympic Games in Mexico. That's more than 45 mph!

For all the excitement, though, it's a vanishing art. It's still in the world championships, after being introduced in 1966, but it vanished from the Olympics even though it extended back to 1908.

You need a lot of nerve if you want to have a go. Two good sprinters can make a pairing, although not necessarily the best. Some of the most successful combinations – like Morelon and Trentin – have brought together a sprinter and a good kilometre rider. The French pairing couldn't have been bettered because they were both the respective world champions at the time.

Despite that brilliant ride at Mexico, they could have gone even better. They didn't, not through lack of ability but because of their very different temperaments. Morelon was cool and detached; Trentin, by contrast, was more fiery, more given to troughs and peaks of depression and exhilaration.

Whatever your pairing, go for a partner of the same height. That'll give you better streamlining. The guy on the front should be the wily sprinter, the tough trackie who can throw the bike about and take the most appalling chances. The stoker, who has to be equally mad but in a different way because he's got his head turned sideways and can't see what's going on, has to be the powerhouse that winds up the sprinter's acceleration.

Perfection comes if you can achieve that pairing and have the lighter man at the back (kilo riders are usually smaller than sprinters anyway). That balances the machine, which has all its heavier bits at the rear. The other thing you need, more important than everything expect the original raw talent, is a telepathic understanding between the two of you.

You have to be able to get out of the saddle together, sprint together, sit

together and do everything together instinctively. It takes a lot of doing, especially for the stoker, who can't see ahead. You can develop it with training, but you can't put natural anticipation where it doesn't exist.

Tandem sprints are more dramatic than solo events, with blunter tactics. Things happen further back so, although the race is still timed over the last 200 metres, things need to be pretty much underway with 500 metres to go. This is because tandems don't have the acceleration of a solo and because their top speed is greater. So they need a longer wind-up time.

To say that tandem racing is won on the last banking makes it sound as predictable as speedway riding. It's generally the case, though. Only on the longest tracks have you got any chance of coming by in the finishing straight. That's simply because of the length of the bike and the space it needs to move out, level up and forge ahead. At 40 mph or so, that can take a long time.

It takes a lot out of a machine. Frame design is a subject in itself, but the other equipment has to be the solo stuff writ large. Wheels are often 36–40 and the gearing 52–55 × 14. Tyres would look right on a road bike, and above all they have to be glued incredibly firmly, with shellac. The alternative is unbearable to think about.

Kilometre time trial

The great problem with the kilometre is that it's too long to be ridden anaerobically but too short to let you recover. Therefore it's extremely vomit-inducing.

There are other contradictions as well. You need a sprinter's power to get away fast – the acceleration period can be critical – but a pursuiter's staying power to keep the gear wound up. Not an easy combination. You also need long cranks and a low gear to drive away from the line, and short cranks and a high gear to keep it going. So which do you choose?

Well, crucial though the opening phase is, I think I'd plump for the strong pursuiter rather than the pursuiting sprinter. The start is around 200 metres, which means a potential loss of about three-quarters of a second from lack of strength and a shade more from too high a gear. I think that should be made up over the succeeding 800 metres.

Trends over the years are certainly going this way. World-class kilo riders now turn 52 × 15 or 50 × 14, although they're probably stronger than you are. Cranks are generally 165 mm, although some riders go to 167·5 or 170. Remember never to copy blindly because you can bet your life that they didn't.

Since you don't have much choice over the way you were born – with plenty of fast-twitch muscle fibres, like a sprinter, or slow-twitch like an

endurance man – all you can do is experiment. There has to be an exact combination of gearing to suit you. And the happy thing is that you can experiment as much as you choose, because all you need is a track, a bike, a coach with a stopwatch, and a small pile of chainrings.

When you've decided, get to the start, get yourself settled, and put your cranks parallel with the down tube, a little higher than a pursuiter's. Grasp the bottom of the bars firmly, take two or three medium breaths and concentrate. Go when you're ready. Remember that you have five seconds between being ready and starting. You can will yourself up a lot in that time.

Then go. Don't put everything you've got into the start or you'll go straight into advanced oxygen debt and you'll die horribly at mid-distance. Start at 75–80 per cent and you'll hit oxygen debt at about 600 metres. You should be able to sustain that pain for another 300 metres and the bike will carry you the rest of the way. If it's any consolation, everybody else feels just as awful.

You can make it worse for yourself if you like by riding up the track a bit. If you have trouble staying down on a shallow bend, keep your eyes a couple of hundred yards ahead rather than immediately in front of your wheel. It's the track equivalent of looking inside a corner on the road; it keeps you turning tightly.

By the way, kilo times vary a lot between tracks and even in different weather. Use your local track to keep a check of your progress, but be aware of what you do somewhere faster. At the same time, watch somebody else's time as well because the comparision will show you whether it's the track or improved fitness that's making you go better.

Madison

If pursuiting and the kilo are the pure events for academic minds and big legs, the madison is the race that every Jack-the-lad wants to ride. It's just as well that they don't actually get round to it because it can be pretty dangerous with all that traffic on the track.

A good madison team is a stayer paired with a sprinter, although both have to be flexible. Tony Doyle and Danny Clark are that – Doyle keeping the laps and Clark gaining them. So were Peter Post and Patrick Sercu, one of the pairings of all time, and later on Eddy Merckx and Sercu.

Sadly, it's rare for amateurs to gain a lap in a British madison, even on the few occasions when they're held on a small track. The last British amateur 'six' (in reality a nightly madison before the professionals took over) was in London; it was a talking point that lasted the week if a team took rather than lost a lap.

Still, the principle is exactly the same even if hard attacking becomes rather pointless given that consistent high speed achieves the same ends.

There are two ways of changing, one for both amateurs and professionals and one for professionals alone. Even so, it's worth learning and practising both because amateurs are allowed to do handslings in some foreign countries and there's no reason the rule won't change here one winter as well.

But first, the throw. Madisons, as you know, are an oval relay race. One rider stays with the race, down at the bottom of the track, while his teammate circles slowly higher up. All you have to do is touch the other rider to put him into the race, but you'd be the only person in the race to do it. Actually, I should say the only *man* in the race, because women never ride.

It saves your partner much more effort and you much more chasing if you throw or push him in. The technique is this:

As you rest at the top of the track, circling gently or (in the case of most British tracks, holding the railings), keep an eye on where your partner is. As he comes within half a straight's distance of you, drop as far down the track as you can, level out and pick up your speed gently as he approaches. Grasp the bottom of the bars firmly.

Your partner will then come alongside below you and grab your shorts with his right hand, tugging them hard to pull himself to a slowdown and to throw you into the race. He'll do it by holding the top of the bars with his left hand, his hand up near the stem with one finger over the very end of it for greater balance. Madison shorts have a reinforced back and an internal pocket in which you stuff newspaper or a strip of sponge to provide a grab-handle. Its position is often marked on the outside by a white strip to make it easy for him.

It's not the idea that he should throw deadweight into the race. You should be accelerating at the moment he grabs you. His throw is to take away the sting of leg pain you get from constant jumping.

You then swing into the line of riders at the first convenient point and he carries on in a straight line until there's a big enough gap in the traffic to get safely back up the track. And that's how you carry on.

You can change every lap and a half on a small track like Harlow, with both riders moving. But on a normal outdoor circuit you've got no choice but to hold the railings and stop. Otherwise it'd be several laps before you met up again and you'd both get shattered.

The professional change is the handsling. It starts in much the same way, except that the fresh rider reaches back with his left hand and holds it, palm outwards, over the grab-handle in his shorts. You then hurtle round, grab his hand, zoom past and tug and sling him into the race. At the last moment he pushes back on your hand for extra acceleration.

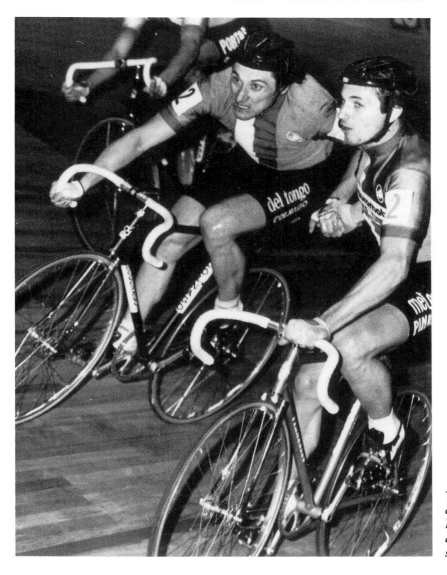

The handsling – fastest change in a madison. Remember you may only change from below the slower rider.

Professionals do it because they've got the knack of not pulling their partners right out of the saddle, either forwards or sideways. With amateurs, the officials aren't so sure.

Generally, you change whenever it suits you. At times, though, you might want to position yourselves differently and change at another interval because of an approaching sprint. If you're not losing laps but you

can't gain them either, intermediate sprints are very important. So's the finishing sprint, of course. It's on the intermediate sprint points that ties are broken.

If you *can* take a lap, good times to attack are when another team is changing, when one of your rivals is throwing its slower man in. You can sometimes use the banking. Follow the field out of the straight but go straight up the banking and straight down again.

Whatever you're doing though, watch, watch, watch to see what everyone else is up to. You have to know not only where the other riders are but also where their partners are. Otherwise you'll come zooming up on a couple who are going to decelerate right in front of you, with dreadful consequences for all concerned. The two rules, apart from that, are to stay in a straight line unless you know you can move up or down, and never to overtake on the inside – just like driving a car, really.

Keeping track of the race is hard on a big outdoor track where there's no scoreboard. It's a bit like being in a doctor's surgery. It's not so much a case of remembering who came in *after* you as who was there when you arrived. Therefore you don't have to remember anybody until they lap you. Anybody who laps you is ahead of you and the rest don't matter.

12 Mud and glory

The first thing to remember about cyclo-cross is that you have to run. Not as much as you did in the past, when organisers fancied the idea was to stop you riding at all, but you do still have to run. The old, cross-bog courses have largely gone (although they return after heavy rain), so all that's left are sudden, steep banks, obstacles and sometimes runs up flights of steps.

As a result, it's wise to go to a race with a variety of shoes. The Spaniards started a fashion for wearing trainers rather than cycling shoes. Shoes like the Adidas Rom, which have a thin but heavily ribbed sole, performed well on and off the bike. They're going out of style again now, but they're still worth thinking about for fastish courses that have dry runs.

For heavier country, though, you have to make a careful choice. Road and track cycling shoes with rigid soles and pronounced shoeplates are out of the question. You can scarcely walk in them, let alone run. Winter shoes are pretty good, especially those originally designed for club runs and touring. The soles are flexible and become more so, and the sides are high enough to stop some of the mud getting in.

You can either wear them as they are, or with specialised shoeplates carrying two small spikes behind the pedal slot, or in really muddy British weather, with a toestrap wrapped round them. You'll find out why the first time you have to run through deep, clinging clay.

The bike, too, needs to be quite different. You can ride a dry 'cross on a conventional road bike with lower gears and heavier tyres. But although the modifications to a specialised 'cross bike are quite minor in themselves, together they make quite a list:

— Wide clearances under the fork crown and rear brake bridge
— Slightly longer wheelbase

— Upright seat tube for hopping on and off, shallow forks for comfort
— Tubulars with heavy, even studded or T-bar, treads
— Cantilever brakes for better clearance and firmer braking
— Handlebar gear levers for greater control
— Slightly lower saddle position for quicker dismounting
— Weighted or double toeclips that hang at the right angle and don't crush
— Wider and lower gears
— Short cranks
— Sometimes a chain guard on the large ring
— No pump pegs or cable clips to dig in while the bike's carried
— A high bottom bracket

The one thing that great cyclo-crossers have is a lot of nerve. It's the realisation of – and the ability to carry into practice – the fact that it's very difficult to fall off a bicycle. The wheels are enormous gyroscopes that work well even at low speeds. And bikes also bridge obstructions like small tree ruts and bumps when they're going faster rather than slower, especially if you jump the front wheel.

You can do a lot by letting the bike take the hammering. I remember at the world championship in London some years ago, watching Rolf Wolfsohl. While others bounced around Crystal Palace, his body was almost motionless above his bike. As he freewheeled down slopes, his cranks were horizontal, his body lifted off the saddle, and his legs were taking the vibrations that came through from the bike. Most star riders have the same ability.

A low upright position, handlebar gear controls and cantilever brakes all spell control for Steve Douce.

The other key factors are timing and a fast start. Stay on your bike as long as you can. It's nearly always faster to ride an obstacle than to run through it. If you come to a standstill, that's it. But do try to keep going.

When you do have to get off, do it quickly. That's where you'll lose a lot of time otherwise. You should be able to dismount either side, but usually it'll be to the left. That's because you'll carry your bike on your right shoulder (the chain and gears are on the right).

Approach the obstacle at speed, freewheel, and disengage your left toeclip. Freewheel to just faster than running speed, press down on the right-hand side of the handlebars, holding the bottoms, and swing your right leg back over the saddle.

Now bring your right leg up between your left leg and the frame, hop your left foot out of the pedal and land on your right foot. Once you're stable, grab the down tube and lift the bike on to your right shoulder.

Like the knack of getting your feet into your toeclips without looking, it's easier (although not much easier) to do than it is to describe. It

If you don't think you can ride it, try it anyway. It's nearly always faster to ride than to run.

certainly helps a lot if you first watch somebody good doing it. The problem is that it's a chicken-and-egg job; you do it best when it's smooth and slick. But how do you make it smooth and slick if you can't do it? Answer: you practise a lot by yourself first.

Run by placing your shoulder just ahead of the angle between the top and seat tubes. The bike will then hang down enough in front for you to loop your right arm through the frame, hold the down tube in the crook of your elbow, and use your hand to grasp the left-lower rung of the bars. That way it'll be secure and your arm will take some of the weight off the flesh of your shoulder.

Remounting is almost the reverse procedure. Without stopping, set the bike down, push it along with the bottom of the bars, and hop on to it by swinging your right leg over the back wheel and saddle in a clumsy vault. This looks easier than dismounting but it's actually a good deal harder.

This brings us to the question of studying the course before you race. While you might be able to get away without it in a time-trial or road race, it's impossible in a cyclo-cross. You have to ride several laps to learn the obstacles and spot the main paths. While you're riding, you may notice that your approach to an obstacle is slow and muddy but the exit smooth and fast. There might be a boggy ride to a bank, a clamber up, and then a

road or firm path at the top. You don't want to get to the path and find yourself in bottom gear when you could use something 20 inches higher for a fast get-away.

Worse, you'll be stuck fast if you go from a fast approach to a muddy slog. It's much harder to get the speed you need to change down. Move into your get-away gear before you jump off. Don't knock the gear levers as you run.

Look on your practice rides for the obvious main route round the course, but look, too, for what could be alternatives when the mud gets churned up. Rabbits and badgers have favourite paths, little wider than a wheel track and roofed over with bracken or fern. Look for them. They're not obvious and the ground will have been pressed firm. Leave these escape routes until late in the race, preferably for when you're riding alone.

If you do have to ride a tricky section, keep your weight on the back wheel by shifting back on to the cantle of the saddle. Pedal down hills as much as you can. Not only will it make you go faster, it'll also make you more stable.

I said a little time ago that the start was important. It is. There are always more starters than any short stretch of the course can accommodate. This means two things: that there's a rope funnel into the first narrow section, and an understandable anxiety not to be left behind at the word go.

After years of false starts (it's more or less impossible to stop a cyclo-cross race once it's started, so everyone careers away at the first cough or twitch), the rules were changed so that the flag is *raised* to start a race and not dropped. That saved a lot of embarrassment for countless town mayors who had only to take the flag in their hands to have everyone zoom off in a cloud of embrocation. It's helped a little, but the truth remains that you can't stop 'em once they've started.

All I can say is, don't make matters worse by deliberately jumping the start, but remember that everyone else might. When they go, you go. Hammer, sprint, do whatever you like, but get to the first narrow bit high up. If you don't, you'll be held up by every backmarker, gear-cruncher and wheel-skidder in the race.

Once you're there, you then use the course to your advantage. You have a big advantage at the front (or near to it, anyway) because you can see where you're going, you're less likely to be held up, and, whenever you pass, there are fewer people to have churned things up before you get there.

You and your big rivals will usually be together. Get by whenever you can. Then control the race. A rideable bank, for example, will have a

whoosh up and a whoosh down. If you whoosh up slightly slower than the bloke behind thought you would, you might actually get him to stall part the way up. Similarly, if you have to run, make sure you go at your pace — even relax a trifle if you're feeling tired — and keep your bike swinging to make it difficult to pass.

Obstacles come in two sorts — natural, small ones, and ones the organisers put there for you. The first include tree roots, drainage channels and so on. You can take these if you're strapped in or if you've got deep channels on your shoeplates. Lift your weight off the saddle a little, grip the bottom of the bars tightly, move your weight back sharply and lift the front wheel over.

Then land your weight immediately back on the front wheel and bend both knees at once. The back wheel will then hop, with luck over the obstacle. Even if you don't clear it entirely, you'll still be moving. The important thing is to clear the front wheel.

The cleverest trick I've seen in a long time was while I lived in Belgium. I'd gone a few miles north, just over the border into Holland, to watch a 'cross on a sopping morning. One of the Dutch specialists was riding. Whenever he approached a tight, 100-degree turn through the mixture of wet leaves and mud, he'd brake first with his front and then with his back and twitch the back wheel round in a broadside turn. Then, as though nothing unusual had happened, he carried on riding. Clever stuff.

Your gearing depends entirely on the circuit. You might consider taking two blocks, perhaps a 15–32 and a 14–28 to use with chainring or rings around 46 teeth. The exact gears don't matter as they would on the track. But you'll kick yourself if you're geared for a slog and the organisers have changed the circuit to include a long farm track.

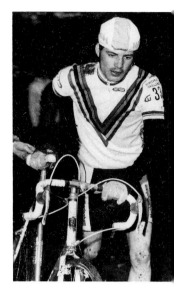

A spare clean bike on the circuit is a great advantage. You switch to it and your helpers clean the old one. This is world champion Stuart Marshall.

13 Looking after yourself

Years ago, the world was divided into two kinds of people. There were the ones that used to go charging about killing buffalo and having a slap-up meal back at the cave. And there were, briefly anyway, the less fortunate ones who got eaten by big angry animals that couldn't take a joke. That meant the good runners survived and the hobblers died out.

It'd be a shame if you wasted all those years in which we (well, you, anyway) turned into a superb athletic species. Training and racing will do you a power of good, but you're hammering yourself. Even after all these centuries, we humans still haven't got the hang of standing upright – there's still a lump at the base of your spine where your tail used to be, and you're more prone to back pains than other animals. Your knees are also made for crouching rather than standing. So it's hardly surprising you ache so much after a thrash with the lads.

Your body needs more than the usual looking after, something at which British riders seem especially bad. Right down to basics, it's embarrassing to hear Continental soigneurs describe British riders as dirty, but I've heard it.

Dirtiness, faulty diet, and poor choice of saddle and clothing cause saddle boils. So can decayed teeth.

Your saddle area has some of the body's softest skin, and some of its least exposed. Sweat can't evaporate or disperse quickly. It soaks into your clothing, turns sour and breeds germs. They then infect the minute abrasions caused by friction and hey presto – the start of a boil. The toxins from a fatty diet and even decayed teeth also take this easy route.

There's not a rider in the world who hasn't had minor skin irritations or eruptions. They come and, generally, they go equally quickly. The problem comes when your own pressure widens the infection instead of letting it come to a head. The poison will spread dangerously and re-

generate itself and before long you have a major problem. Eventually, as some senior professionals have discovered, you've got something that can be cured only by dangerous surgery.

If you suffer from saddle infections, consider these points:

— Do you wash your racing shorts after *every* race? Jackie Simes, the first American to break into the modern six-day circuit, reckoned he needed three or four pairs of shorts for every evening of a six-day event;

— Does your underwear have seams which overlap in the saddle area? Clothing seams are made in two ways: in flat, edge-to-edge joins, which are ideal, or by folding the ends, interlocking them and sewing through the extra thickness;

— Is the chamois – or artificial substitute – in your shorts torn, abraded or too thin?

— Is the chamois hardened and rough, or stretched by being wrung in washing? Wash chamois only in soap flakes, not detergent. You can soften it with lanoline or commercial creams, but remember that you'll have to wash it more

— Can you cut down on fatty food? Fat gives food its flavour, which is why the tastiest food turns you barrel-shaped, but it also changes your sweat. 'Fatty' sweat can bring skin infections;

— Could you increase the vitamin B in your diet? There's a theory that it'll help. Vitamin B comes in bread, liver and roe, and much else besides;

— Do you eat enough fresh fruit, particularly oranges? You can't eat too much vitamin C – any surplus gets washed away – and what you absorb helps you recover;

— Do you wear your racing shorts after the race, or for the journey home? Remember that you've sweated hard, whether you feel wet or not;

— Are you scrupulous about washing your crotch as soon as possible after the race, even if you can't manage to shower or bath until you get home?

— Do you use soap and water as well as toilet paper?

— Might you be changing the acid balance of your skin? It has to maintain a particular balance to produce its own disinfectant. Some people find that ordinary soap changes that acid balance. It doesn't bother them elsewhere, but it might effect you where it's most important. If you're not sure, use a soap with a neutral acid balance. It costs a bit more – you can buy it as a concentrated liquid from chemists – but it's worth it;

– Have you considered dabbing the area with alcohol? (Warning: it stings. And never use alcohol instead of soap and water);

– Have you considered your saddle? Leather needs occasional wipes with disinfectant. But the newer designs have leather or artificial padded coverings fixed to plastic bases. The covering can loosen under the pressure of riding. It ridges a little under you and starts wearing you away. You can't spot this looseness, so try another saddle for a while to see what happens.

So what do you do if, despite all this, you do get a saddle boil? First re-check all the likely causes, particularly cleanliness. Then remember that the best way to get rid of the infection is not to ride. Riding with a boil is risky and it's also shatteringly painful. Fortunately, infection clears up fast when you're fit – provided you didn't get the trouble in the first place because you're run down.

Never lance a boil. If it *does* have to be done, remember it's surgery and a job for a doctor. I know you hear tales of riders lancing boils in stage races and, on one occasion, immediately before an important '100', but the risks are tremendous.

A greater number of nerves come together in the saddle area and infection will spread very fast round the body. You also run a good chance of skin poisoning, blood poisoning and heaven knows what else. What's that worth, when the alternative is just a short time off racing?

Catch the boil before it gets to that stage. Change your saddle, or even just your saddle height, so that the pressure falls differently. Wash the area two or three times a day with medicated soap and finish off with alcohol. The problem should go within three or four days.

Let me say again – the only sure way to end a saddle boil is to stop riding, and that the consequences of worsened infection are considerable. If for some reason you have to ride just one more race – and be strict with yourself – you might find some pain-killing salve and some aspirin might help. But medical treatment must follow immediately.

Other problems

Knee pains have various causes. They can come on through exposure to cold air and driving rain during early training or racing; more likely, they're caused by poorly fitted or worn shoeplates, or worn pedal cages. Shoeplates wear fastest on the outside, and so do the alloy frames of pedals. The result is that your foot tilts and makes your knee operate at an angle. One remedy is to stop using metal shoeplates, which thankfully are fast disappearing. The problem usually goes as soon as you replace the shoeplates or pedals.

Remember when you buy cycling shoes that there's no practical alternative nowadays to shoes with adjustable plates already fitted. It can take several days to get the plate in the right position, but if the alternative is to have it wrong for ever because you can't be bothered to pull the nails out and start again, there's surely no further argument.

Cold-weather injuries used to be called 'Easter knees' in the days when tradition had it that riders switched solely to shorts every Easter, regardless of how early it fell. The solution, generally, is to dress more sensibly and to ride a lower gear. We were never meant to bear heavy weights on bent knees, so you might as well make it easier for your joints by lowering the gear in winter and spring.

Back pains are usually the result of weak back muscles. Cycling in a crouch stretches the muscles that run either side of the spine, while at the same time strengthening the ones that bend you to the side (from the motion induced by plodding up hills). The spinal muscles become so stretched that they have to contract a very great deal simply to support your weight. This makes them tired and, like most things that get tired, they begin to ache.

The solution is to strengthen and shorten them. Mobility and weight training is the answer. So, too, might be making your position less severe. Perhaps you could raise your handlebars or shorten your stem. Remember that back pain rarely comes from too *short* a position (that just causes other snags).

It's hard to determine just where back pain is coming from, but a pain more to one side of the spine than the other could suggest you've got one leg fractionally longer than the other. Lots of people have. At least one of the riders I've known over the years had this diagnosis made by a physiotherapist. He was compensating by riding at a slight tilt, just as he did when he walked, to avoid limping; a pad for his shoes solved the problem.

Finally, you'll also get back pain in the same way you get Easter knees – by leaving the small of your back poorly covered. You sweat a lot there and bare flesh or chilling sweat can leave you feeling sore. That's why it was good news when shoulder bags went out of fashion, because they made you sweat more.

Three other problems that commonly beset bikies are an eye infection called conjunctivitis, an anal infection called piles, and constipation. They're all easy to treat, all a nuisance, and all a consequence of riding in the wind and rain or of getting dried up.

Conjunctivitis is an inflammation of the conjunctiva, which is the membrane over the front of the eye. The eye becomes bloodshot as the blood vessels dilate. But don't worry if you've got just bloodshot eyes,

because you'll get that as an unavoidable spin-off from riding a bike. You get it from wind blowing on your eyes, and from dust and smoke. You can even, although not often, get a soreness from the bleary image your eyes get from looking through tears. If that sounds like you, try wearing sunglasses that react to light.

Unfortunately, the redness once acquired can stay with you for years.

Full conjunctivitis produces a sticky discharge, which can stick your eyelids together in the morning. It's highly infectious, so don't touch the infected eye or you'll spread it to the other.

It lasts about a fortnight. Treat it by washing your eyes with cotton wool soaked in boric acid, and throw it away after each wipe. Keep your fingers away from your eyes. You can also smear the lids with a light antiseptic ointment to stop them gumming up. Apart from that, and wearing dark glasses, there's not much you need to do.

Piles, caught early enough, at the irritation stage, are cured by absolute cleanliness and treatment with an antiseptic cream such as TCP. About one bike rider in five seems to get them; rather fewer admit to them. Piles – or haemorrhoids as you may know them – can be internal or external. They're enlarged veins in the rectum. You'll probably get the external version. You can have them for years; you might not even know you've got them except for an occasional cutting pain during bowel movements. Every time you ride in the rain, though, you might make them worse. They can't live happily with wide changes in temperature, from the heat and warm damp of your shorts to cold water spraying off your back wheel. Eventually it becomes painful to sit or even to walk in tight clothing.

So what do you do? First try to avoid the causes. Use a plastic saddle with a lot of padding to try to stop the cold coming through from the bottom of the saddle. Then switch to shorts with extra-thick padded chamois.

Wash the area thoroughly with soap and water, keeping it scrupulously clean. Wipe on the antiseptic cream. That should be enough to reduce the irritation and it may cure the whole problem. In extreme cases, you may need surgery.

If you're prone to piles, take extra care to avoid constipation. Constipation is caused by drinking too little, or by eating at the wrong intervals before a race. The adrenalin that floods into your body when you're excited shunts blood away from the spleen and the stomach and into the muscles; your digestive system, therefore, is starved of the energy it needs. That, by the way, is a good reason to avoid a lot of solid food during races. At the same time, the food in the colon becomes drier. The fluid that lubricates it is being used for sweat and to stop the blood thickening.

You can get rid of constipation with pills and potions, but they upset your internal balance (your 'form') and you'll always wonder what effect commercial preparations might have on a drug test. Better, then, to use suppositories. They're messy but they solve the basic problem by lubricating the passage for the faeces. Follow it up with plenty to drink.

Massage

I used to use a reeking spirit called Curacho, which felt freezing and made everyone's eyes water. It came in small, opaque plastic bottles. Then we discovered Musclor, which not only came in three grades, so that we could pretend we knew what we were doing, but also had a lot of French text and some confusing and gory diagrams of muscles.

I don't blame the Curacho people – it never did any good because all I ever did was wipe it on. Actually, I never did much good with Musclor, either, but that was more my fault than theirs.

Massage, like scratching your back, is one of those things that are difficult to do yourself. You can't get to the bits that matter. On the other hand, you can make a fair stab at it. And for that you need to know the principles.

Blood travels sugared and oxygenated through the centre of your body (the exceptions are the arteries in your wrist and neck). It flows into arterioles and then into the muscles. An electrical charge from nerves burns the sugar in the oxygen and produces carbon dioxide and toxins, such as acid and burnt sugars.

There's another system for getting rid of the waste, but it depends on the blood getting back into the major veins. The heart doesn't do this bit of the job. Instead, your lungs compress and milk the veins in the upper body and bring the blood through the air sacs ready for oxygenation. The blood flows on into the heart, creates a vacuum behind it, and more blood is drawn up from the muscles.

In most cases, the dirty blood has to go uphill – from your legs, for example. A four or five-foot tube of blood is more than the vacuum can lift, so it travels in stages, a bit like a lift, with small valves to stop it dropping back down again.

Massage is a mechanical way of squeezing the blood from one chamber to the next, via the valves, and on into the general circulation. You do it by grasping, stroking and squeezing.

All the big Continental teams employ their own masseur, a bloke who, on the poorer teams anyway, has a pretty rough life because he doubles as the baggage handler and car driver. Maybe you're lucky and you've got a

qualified masseur in your area, even in your club. You might find, if you're willing to pay (and heaven's sake, stinginess is no reason why not), that you can strike up a good relationship with the physiotherapist at your local professional football club. First division clubs have their own on the staff, but the lesser lights employ freelances who might be glad of a little extra custom. Certainly he'd be worth getting to know, anyway, because sports physiotherapists have a much better understanding of an athlete's aches and pains than a National Health doctor rushed off his feet by fat women with bunions.

Failing all that, you can have a reasonably good go at massaging yourself – at least, you can massage all the bits you can reach. It stands to reason you can't rub your own back muscles.

So, start by having a warm shower. That's essential, otherwise you'll rub all the muck and rubbish into your pores. Lie down for five minutes with your legs propped up, then sit against a wall or the bed headboard and begin.

The first thing to remember is that, since the system is one-way, there's no point in massaging away from the heart. Always start at what physiologists call the distal end – the bit furthest away from the rest of you – and work inwards.

Start by stroking the muscle with the palm and heel of your hand, using your fingers – kept together – and your thumb to lift the muscle. Start the stroke lightly and increase the pressure, remembering to stroke along the whole muscle without stopping, to end the stroke with a squeeze, and to come back to the other end of the muscle without breaking contact with the skin.

The theory is that breaking contact makes the nerves react and the muscle tighten slightly. It's the smoothness of the action, and the fact that it's easier to do it with some sort of lubricant, like baby oil or embrocation cream, that first started racing cyclists shaving their legs. It's difficult to massage legs soothingly if some ham-fisted masseur keeps catching the hair between his fingers.

Note that you don't have to use commercial embrocation. Indeed, masseurs rarely do. They prefer talcum powder, which is clean, or baby oil. You can even use warm, soapy water. Thick creams and greases should never be used. If you've shaved your legs and dried them thoroughly after a shower, you don't need anything at all, which is much more relaxing after a hard day's riding because you don't have to go and wash all the stuff off again.

By the way, make sure you have warm hands.

Work smoothly but increasingly firmly towards your heart and lymph glands. You'll be most interested in stopping your legs aching, so the

lymph glands in that case are behind the knees and in the groin. Bring your fingers and palm together at the end of each stroke, squeezing the end of the muscle to milk it. The same action means you let go of the muscle gently, ready to return to the start of the stroke.

After a minute or two of stroking, you're ready to move on to the deeper action of kneading. This tones up the muscles and gets the blood and lymph flowing. Kneading's difficult to do on your own legs, because you need both hands, but it's worth having a go. The idea is that you extend the muscle-lifting action of stroking into a rhythmical rolling and squeezing, bringing your hands together as you lift the muscle, keeping the motion working towards the heart all the time. Remember that you're kneading – lifting and squeezing forward – and not wringing. You might have the most dynamic legs in the world, but they're still delicate. Don't try wringing them out like a wet rag.

Done properly, you'll feel the kneading action bringing gentle relief with each stroke. Carry on until there's no apparent improvement and then move on to percussion.

Now, this is the bit that you always associate with Swedish masseuses, plus being slapped with birch twigs. The idea is to stimulate the musles. Some people employ strapping great Swedes, some karate chop their limbs, others making clopping sounds by cupping their hands and tapping

Perfection is a skilled masseur – the late Bill Shillibeer gets to work on Keith Lambert – but you can do a fair job yourself.

their muscles. I recommend the simplest way of all – you just take the muscle gently with your fingers, lift it a little, and wobble it. That's all you need. Wobble it progressively from the outside inwards and repeat several times. Then finish off with more simple stroking actions to calm the system down again. And that's it.

There are other things that a proper masseur can do – like sorting out lesions and so on – but leave that to the masseurs. You won't do much to damage your muscles seriously, but there's no point turning up bruised from shorts to ankle socks.

Crash!

The day I rode my first road race, I also had my first road race crash. I still don't know what happened. One moment I was away in a break on the bottom straight at Crystal Palace, the next I was bouncing along on the ground with two or three others. Behind us were around a hundred and fifty others; all about us were bits of bike, pumps, riders and heaven knows what else. I ended up sitting cross-legged, seeing the mass bear down on me and finally parting to spill round me and the other unfortunates. Not one pedal touched me; not one other rider fell off. And ever since then I've taken a great interest in crash injuries.

You can crash in any race. You can even crash in a time-trial – as an embarrassing number of people prove each weekend. But it's most likely, of course, in a road or track race.

When it happens, it's unexpected. And it nearly always hurts. What's more, since it generally happens outdoors, there's a fair risk of contracting tetanus. Tetanus is a fatal affliction which comes from picking up germs carried by animals and birds. They cross or touch the road and leave the germs behind. You scoop them up as your skin tears on impact with the ground. It's possible, although fortunately not too likely, that you'll be dead within a fortnight. The wetter the road and the wetter the wound, the more likely you are to become infected.

When you go to hospital to have all the bits patched up, there'll be great enthusiasm to inject you. They want to put a small dose of tetanus into your system to start the defence mechanism against the larger dose that might be on its way from the wound. It's a method that sounds crazy but actually works very well.

The drawback is that it's deliberately making you ill. The chances are against you actually having potential tetanus; but it's as good as certain that the injection will take the edge off your form. You can't ride as fast as possible if you've got a mild dose of tetanus which you're fighting off.

There's no point in trying to talk to the nurses about this. I've seen hardened British professionals trying and failing to talk their way out of a tetanus jab after a multiple crash on the Isle of Wight. You fall off and you'll get a jab . . . unless . . .

You *won't* have a needle stuck into you mid-season if you had a course of voluntary injections during the winter. That's the sensible way, because it doesn't matter much if you're slightly off-form in November (unless you're a 'cross specialist, of course, in which case you should volunteer for injections in the summer). Your own doctor will be delighted to do the job for you, but you might have to give him a few days' notice so that he can get the vaccine in stock.

The injections don't last for ever. Ask your doctor for a card showing the dates of treatment and either take it to races with you or remember when you had the last injection. You can be sure that the casualty department will want the information.

And now back to the injury . . .

It was accepted knowledge once that injuries should be heavily protected from further infection. You'd walk out of casualty in swathes of bandages. Now it's just the opposite. Current belief is that wounds heal faster if they're exposed to the air. Instead of the bandages, you'll either get nothing or you'll get a clever, light pad with a plastic coating. The coating covers the wound and separates it from the pad; the scab is therefore kept to a minimum and it doesn't get ripped off painfully when you want to change the dressing. Clever stuff.

The only first aid you need at the roadside is to stop the bleeding and to clean the wound. It's very unlikely that you'll bleed profusely from a bike accident. If you *do*, raise the injured bit to make it harder for arterial blood to get to it, apply a pad – a clean handkerchief, for example – and press. The greater the bleeding, the greater the pressure. You'll almost certainly end up with blood everywhere but, if it's any consolation, it takes an awful lot of time to lose a lot of blood from anything but a broken artery.

The usual injuries are deep grazes to knees and elbows. They may even be deep enough to expose a small area of bone. It's dramatic but it's not necessarily serious.

Clean the wound with water, using a fair amount and washing from the centre of the cut outwards. Gravel and grit are the biggest problems. They almost always mean a visit to hospital for expert flushing. Don't underestimate the problem caused by leaving a wound uncleaned. Do what you can and get to hospital to have the job finished off.

Once you're patched up, exercise gently. That'll stop too deep a scab forming and it'll help disperse bruising.

Broken bones are altogether more difficult, of course. All you can do is isolate and support the break, either with a sling (a high one for a broken collar bone, with the knot on the *unbroken* side, please, and the elbow well supported), or by strapping it to something rigid (one leg against the other, for example).

Luckily, broken bones are rare in cycling. The worst you're likely to get is a snapped collar bone. But a word of warning here if you're the man on the spot at a bad crash:

Remember that you can't always *see* a broken bone. It looks very dramatic when a leg or an arm bends in a direction that it shouldn't, or just goes floppy, but it's not necessarily dangerous. Nor, necessarily, are bones that stick through skin. No, the worst injuries are the ones you can't see — injuries to the spine.

When you rush to care for a clubmate lying in the road, watch to see whether he moves both arms and both legs. It's essential that you don't move him — unless his life is in immediate danger from petrol, perhaps — if there is no sensation in the legs. Ask him to move his legs on some pretext, or ask where the pain is. Any absence of movement and pain might show spinal damage.

Again, before you help him up, feel for breaks in the collar bone. If there are any, rest the damaged arm across his chest, like Napoleon, and carry him horizontally off the road. Then, supporting the damaged arm totally, make a sling. If you can't, it's acceptable to hold the arm bent across the chest, the hand up by the unbroken collarbone, and the elbow supported by the other hand. Just move as little as possible and call for first aid.

The chances of bashing your head are also fairly small, although the Americans rate them seriously enough to insist that riders there wear full-scale crash helmets. Be careful to wash any head injury because the skin's thin and there's not much room between your hair and your skull.

Don't drive home if you've bashed your head. Concussion, like all forms of shock, can take hours to appear. It's not serious in itself but only because of the dangers of wandering about suffering from it. That's why hospitals keep you in — to protect you from yourself. The symptoms are a rise in body temperature, a fast pulse, a headache, and perhaps slight dizziness and vomiting. Normally any fainting is soon over and you're recovered within a day.

Don't get back on your bike for two or three days after knocking your head, then try gently — on rollers if possible, just in case you do come over dizzy again. The chances are very much that you won't, but it's better to tumble into a kitchen table and chairs as your blood pressure rises than it is to collapse under a baker's van.

Let me say again — the chances of knocking your head are very, very

slight. And although there is great commercial hysteria and pressure to persuade us all to wear enormous plastic helmets – it's no coincidence that America was the first to make them and the first to succumb – the helmets *aren't* designed for full-impact collisions and they can prove a distraction greater than the original risk of falling. Wear one if you wish, but don't depend on it.

Now, what to do if you catch a cold or flu. There's a great distinction. A cold, however runny your nose, is a minor irritation which will pass in a few days. Any athlete is more prone to catch one than the rest of the population because his body is more stressed and his resistance lower. The fact that they tend not to get them so often is because they spend most of their time outdoors with other healthy people. You gain, too, as a bike rider because you can use your bike instead of public transport.

You can judge a cold by the difficulties it gives you. You won't feel your best but you can generally carry on riding, even if not training in the true sense. It might even make it pass more quickly, particularly if you wrap yourself up very securely. Don't, though, go to extremes – no mega-riding which will lay you low and open you to other troubles.

Flu is altogether different. It's much more of a medical condition and a relatively dangerous one. Luckily it's quite rare and often goes in epidemics. A cold is an irritation that makes you feel rotten. Flu can put you in bed, totally drained, for several days. There is no alternative but to do whatever a doctor tells you. There are no shortcuts.

After that, it will take you another ten days to two weeks to recover. The infection is passed but you're weak. Start with reduced training and easier races. Judge yourself carefully and increase the load gently until you're back in form. Then give it all you've got.

Finally, it stands to reason that a book like this can't list everything you *might* get. And anyway, the chances are that you won't get it. If you're young and at school, just console yourself that you're in one of the most unhealthy places in the world and your continual stream of infections will dry up when you leave.

14 Racing abroad

Nobody knows for sure who were the pioneers to break into overseas racing. We'd always sent teams to world championships abroad, of course, and by and large they did no better then than they do now. But to race on the Continent just for the hell of it?

It probably happened during the era of Percy Stallard, the pioneer of British road racing between the wars – who got banned by the NCU for life for his troubles. They shoved a few francs in an envelope, posted them to France, and then went across to see what happened next. What they found inspired them to start something similar here, and so ended years of secrecy so far as racing on the public roads was concerned.

The answers to the question *why* are that it's different, it's often faster and harder, the prizes are higher (although more difficult to win) and there's a direct, although competitive, link between riding as an amateur and starting a career as a professional.

The easiest options for British riders are Holland and Belgium, probably in that order. Holland has fewer races than Belgium, but they're better organised and the country is a shade more hospitable (although more expensive). Belgium is still the one country where cycling is truly a national sport, but the atmosphere is seedier. I'm not going to mention France in detail because it's so big and so regional that it's hard to generalise. There are tough areas and there are regions where you'll face no tougher opposition than in Britain – but events are much further apart if you want variety. I suggest, if you want to race in France (or another country not mentioned) that you contact either somebody you know has been there recently and/or write to the national association. I'll give you the most useful addresses later.

The real thrill of Dutch racing has always been the criterium. Indeed, only the biggest races – many open only to Dutchmen – aren't criteriums.

Racing on the open road in such a crowded country is limited to the national professional and amateur tours, the Amstel Goldrace, and a handful of amateur classics.

Planning for a Dutch criterium starts a year in advance. The town hall is contacted, a deal is worked out, and the men from the ministry close the roads. The organisers can erect barriers and charge spectators a few guilders, but a few cents from each guilder go to the town hall. The householders get a day's free entertainment in return for moving their cars, and everyone seems happy.

The Dutch have six categories:

1 Amateurs (men over 19)
2 Juniors (17 and 18)
3 *Nieuwelingen* (15 and 16)
4 *Liefhebbers* (of which more in a moment)
5 Veterans (over 35)
6 Women.

Those are the classes recognised by the KNWU, the national body, but there are extra races run by an unofficial body for under-15s. This unofficial body, being unrecognised by the KNWU and UCI, is outlawed by the BCF as well. Still, nobody in Holland seems much bothered and the cycling world's full of riders who came up in the pirate body and moved on to the KNWU. There are also no small number of British riders who've competed under the pirate rules and been left untroubled by the BCF.

The *liefhebber* class isn't available to non-Dutchmen. It's a category for riders who race to enjoy themselves rather than to win money – the motive which drives most Dutch amateurs, the word being only loosely applied by Olympic standards. A senior can elect to move to the *liefhebber* class whenever he wishes, but he's there for the season. He can't pick and choose. The word translates loosely as 'enthusiast'.

Amateurs – seniors – have three standard prize lists, called *schemas*. They're laid down by the KNWU and can't be varied. You'll find races listed in the KNWU magazine, *Wielersport*, listed by their prize list and not, as in Britain, by category of rider. The best riders obviously go for the richest races, so perhaps the result is the same.

Since the prizes are the same, right down to 20th place, organisers compete with the primes they offer. Primes are a giant feature of a Dutch criterium. They're offered not just to the leading rider but to the next two or even three as well. There can be primes for the leaders, primes for the chasers, and even miniature points races for even more primes. You'll hear

them announced – in Dutch, inconveniently – by the commentator. The news comes with a lap to go and the word to listen for is *premie*, pronounced 'pray-mee'.

Dutch circuits are about a mile long, usually a square with one side running through a village, or through a housing estate. Surfaces are generally *klinkers*, or a kind of stone parquet of intermediate quality. They're not cobbles, but they're not smooth tar either.

Dutch riders can enter on the line (*bijschrijving*) or in advance (*aanschrijving*). The races are listed in *Wielersport* with very little indication of where the village is. You'll simply see 'Oudenbosch, NB', from which you're to conclude that it's in the province of Noord-Brabant. They have double postcards which they complete and send to the organiser; the organiser keeps one half and returns the other as confirmation. The better and the more hopeful ask for a start fee, tactfully described as expenses (*vergoeding*), by scribbling their price on one of the cards. The organiser can accept the cost, amend it, or reject it completely. The rider is then committed to ride, whether he's getting expenses or not, and the KNWU will fine him if he doesn't turn up. The fines are listed in each *Wieldersport*, along with the suspensions that the *liefhebbers* collect for not turning up.

Dutch organisers will sometimes take advance entries from British riders, but they're not supposed to. They invariably take entries on the line. Present yourself to the chief judge, usually on a lorry trailer by the finish line, and present your BCF international licence. The judge will look at it, scratch his head, and enter you to the list. There's no entry fee.

There's also no changing room, so you either go changed, or you do what the Dutch do and knock on doors nearby and ask for a room to change in or a back shed or garage.

Dutch riders start like startled panthers, thrashing off up the road immediately. The opening pace is ludicrously high because the circuits are short and tight. But the speed does settle down – a little. Nobody gets lapped, except by mistake. If you're in danger, the commentator will tell your group to sprint for the line before the distance is up. He'll tell you in Dutch, of course, but at least you'll know why everyone's suddenly going hammer and tongs for the finish (*aankomst*). You'll be credited with the place you held in the race at the time.

Prizes and primes are paid out on the spot, along with your returned licence.

Seniors ride around 100 km, juniors around 40 km and schoolboys about 20 km. There are gear restrictions for juniors and schoolboys, so check in good time what they are in the season you want to go. Women riders, whom the Dutch have produced in quality over the years – Keetie

van Oosten-Hage, Petra De Bruin and so on – have fewer races, over about 50 km.

The KNWU (Koningklijke Nederlandse Wielren Unie) is at Polanerbaan 15, 3447GN Woerden.

Belgium used to have a season of road races either in the British style, round long circuits, or from place to place. The classics, like Omloop Het Volk, Gent-Wevelgem and the Tour of Flanders, are still run that way. But a chap called Jan van Buggenhout changed that when he realised there was money to be made from signing the best riders and then organising criteriums for them. Before long he was signing them out to other criterium organisers as well, and the face of Belgian racing changed irrevocably. Like neighbouring Holland, place-to-place races, unless designated international, are now open only to Belgians.

The governing body in Belgium is called the BWB and it's based in Brussels, in Globelaan. It's also called the LVB and it's based in Avenue du Globe. Both, of course, are the same people. The distinction comes because Belgium is a nation with three national languages – Dutch, French and German. So few people speak German that you need worry only about Dutch and French.

Draw a line east-west so that it passes just south of Brussels, and you'll find that everyone to the north speaks Dutch (or Flemish, as national pride makes them call it) and everyone to the south, French. The north is called Flanders (*Vlaanderen*) and the south Wallonia (*Wallonie*). The only bilingual part is the city of Brussels, even though it's actually in Flanders. In practice, though, most Flemings will speak French if they have to, whereas the Walloons refuse to learn Dutch; that means that Brussels is bi-lingual in theory but French in practice.

Bike racing is a national sport but the best riders and the greatest concentration of races are undeniably in northern and more prosperous Flanders. For every good southern Belgian – Claude Criquielion, Jean-Luc van den Broucke – there are a dozen from Flanders.

Belgians have just four categories:

1 Seniors (called *liefhebbers* in the north and *amateurs* in the south)
2 Juniors (under 19)
3 Schoolboys (*nieuwelingen* in the north, *cadets* in the south)
4 Women (called *dames* by both sides but pronounced differently).

The important thing to remember is that Belgian *liefhebbers* have absolutely nothing to do with their namesake in Holland. The translation is the same, but the distinction in a Belgian mind is between amateur and professional, not between serious and less serious.

In fact, at one time there was little distinction between any of the amateur categories, and no restriction on distances or frequency of racing. In the 1960s, though, the government became concerned at the health risks that some riders were taking, with youngsters doping themselves and missing school to ride tough races. The BWB was forced to react.

Even now, under government influence, juniors and schoolboys are allowed to race only twice a week and are not allowed to race outside Belgium except, in the case of juniors, in infrequent national teams.

The reverse of that is that foreigners aren't allowed to ride in schoolboy races and aren't supposed to ride junior ones. But this is Belgium, so what the rule now says is that you can race in Belgium provided you have a 'guardian' there, which in practice means being adopted by a local club. And, this being Belgium again, what actually happens is often rather different: most organisers will accept you without question as a foreigner in junior events. But be prepared to be rejected (which is what the rules say) or not to get your prizes (an arbitrary rule at the whim of the organiser on the day, and which you'll assuredly not be told of in advance). You just have to shrug and accept that it's their country and not yours, and that anything you get is a favour and not a right.

When the government intervened to impose age limits, they also stopped roads being entirely closed for most races. Keen though most Belgians are on cycling, they also got pretty miffed about being delayed and detoured wherever they went. Belgium is only a small country, rather smaller than East Anglia, so your chance of being held up by a bike race was quite high, particularly since all you need to close the roads is the agreement of the local mayor.

What happens now is that the roads are closed while the race passes. You can't do that on short circuits, so Belgian races are now on loops of about five miles. The police lend a hand, stopping traffic at junctions, and local marshals are given national authority by being given those little lollipop-shaped batons you've probably seen in photographs.

Road surfaces can vary between excellent and excruciating within a few miles. You can be on smooth cement, then hit the roughest of cobbles, then turn on to a brief stretch of sandy path, and find yourself back on cement, all within ten minutes. As a result, Belgians are very adept at exploiting the effect these roads have on others. They're also natty bike handlers, and they also, in the north at any rate, sit a little lower on their bikes than the British or the French.

Northern circuits are invariably flat – hills like the Koppenberg are freaks – but southern races have the benefit of rolling countryside and small mountains, the Ardennes. Northern Belgium is also windy, particularly near the coast.

Distances – seniors ride around 100 km, juniors about 80 km.

Entries are all taken on the line and you'll find the details either in the BWB's scruffy little magazine, *Cyclo-sprint*, or much more practically in the daily papers. Belgian papers are all regional, published in Brussels, Ghent, Antwerp, for example, and concentrating on those areas, but they're also national in outlook. So, on the sports pages, you'll find a sports calendar for the day. The two best papers are *Het Volk* and *Het Laatste Nieuws*, although the others are pretty good. If you read Dutch, *Het Volk* has the best coverage, but *Het Laatste Nieuws* has the best photographs.

There's only one prize list for each category and primes are less frequent than in Holland. They're also offered more erratically; you can be sure of primes on the line in Holland, but you may find them outside individual shops in Belgium, for publicity's sake. Races start slower than in Holland but gather speed as they go.

Entering a race in Belgium is a question of finding the pub (*café*) being used as the race headquarters. Again like Holland, there's no changing room; it's also against the law to change clothes by the roadside, although it occasionally happens.

You'll notice in Belgium, by the way, that many racing cyclists have small reflectors on their back brakes. They're there because they've not bothered to take them off; you see, the law requires bikes to have reflectors on the pedals, a white reflector on the front and a red one on the back. They also have to show a tax plate – about 60 francs a year and a different colour for every province. You don't have to have all these widgets in place during a race, but a lot of riders can't be bothered to take them all off. These rules also apply to you if you're renting or buying accommodation in Belgium. You also, by the way, have to carry your passport with you wherever you go (Belgians have to carry an identification card).

The BWB (Belgische Wielerbond) is at Globelaan 49, 1190 Brussel, or in French, the Ligue Vélocipedique Belge, at Avenue du Globe, 49, 1190 Bruxelles.

Outside the BWB, there's a thriving calendar of unlicensed races. The prizes are much smaller and the distance a little less, but the pace is still pretty frantic. There doesn't seem to be any objection from cycling or state authorities – indeed, the police turn up to help just the same. The standard is about the same as a first and second category road race in Britain, although obviously they vary. Keep your eyes open for posters in bike shops (every village has a good bike shop), shops and bars. There are no entry fees for any races in Belgium, but you may be asked for a deposit for your number and you'll also have to pay a small sum for a day's insurance.

The Fédération Française de Cyclisme is at 43 rue de Dunkerque, 75462 Paris Cédex 10 (tel. 285.41.20).

Other national bodies:
Australia: the Australian Amateur Cycling Association, 20 Paterson Crescent, Morphettville 5043, South Australia (tel: 295.6178)
Austria: the Österreichscher Radsport-Verband, Prinz Eugenstrasse, 1040 Vienna (tel: 65.73.39)
Canada: the Canadian Cycling Association, 333 River Road, Vanier, Ottawa K1L 8B9, Ontario (tel: 613–746.5753)
Denmark: the Danmarks Cyckle Union, Idraettens Hus, 2600 Glostrup
Finland: the Suomen Pyöräilyiitto, Topeliuksenkatu 41a, Box 25202, Helsinki 25
Ireland: the Irish Cycling Federation, 9 Casement Park, Finlas West, Dublin 11
Israel: the Sports Federation of Israel, PO Box 4575, 4 Marmorek Street, Tel Aviv
Italy: Italian Cycle Federation, Via Leopardo Franchetti 2, Rome
Luxembourg: the Cycling Federation of Luxembourg, PO Box 2253, Luxembourg
Malta: the Amateur Cycling Association, PO Box 293, Valetta
Morocco: Royal Cycling Federation of Morocco, Vélodrome d'Anfa, Bd Adellatif ben Kaddour, Casablanca
New Zealand: the New Zealand Amateur Cycling Association, PO Box 3104, Wellington
Norway: the Norges Cyckleforbund, Hauger Skolevei 1, 1351–Rud, Oslo (tel: 02–134290)
Portugal: the Federacao Portuguesa de Ciclismo, Rua Barros Quero 39–10, Lisboa
Spain: the Federación Española de Ciclismo, Calle Ferraz 16–50, Madrid 8
Sweden: the Cykelfrämjandet, PO Box 2085, 103 12 Stokholm
Switzerland: the Comité National du Cyclisme, PO Box 930, 1211 Geneva 3
USA: US Cycling Federation, 1750 East Boulder Street, Colorado Springs, CO 80909
USSR: the USSR Cycling Federation, Skaternyi Peruelok 4, Moscow 69
West Germany: Bund Deutscher Radfahrer eV, Otto-Fleck-Schneise 4, 6000 Frankfurt-am-Mein 71

When I lived in Belgium, I found contacts for no small number of British and American lads who wanted to come over. One or two were with clubs

in the Antwerp area and the rest were in the Noord-Brabant and Zeeland provinces of Holland. I'm afraid that after a year, I stopped.

I'm embarrassed to say it but, with a handful of exceptions, the riders I helped abused the privilege that their hosts were offering. The shame was that it was the British and not the Americans who caused the problem. One American didn't get on with his host family but lived very happily with another, but the British – with those exceptions – soon came to regard their hosts as sponsors or even servants.

The families complained of abuse, laziness, general slovenliness (something guaranteed to offend the prim Dutch) and, in one case, of a lad who cleared off overnight, owing a week's rent and, as it turned out, a heck of a lot on the telephone bill. There were families that were disappointments, too, of course, but why should British lads be so consistently a let-down? Why should they lack common courtesy, goodwill, energy and a willingness to survive and get on? Those happy exceptions became local personalities, welcomed and helped wherever they went. They were given better chances than many of the Dutch and Belgian boys. But the others were told to leave within a month or two.

I'm sure you won't go to the Continent with the same attitude. Remember that you will certainly get away with almost anything if you act badly and clear off quickly enough. But every time you do, you close the door on somebody else for a very long time.

15 When all's said and done

I was at a clubroom some years ago when an old friend called Roy Thame was there. At the time he managed national teams off and on and also, full time, the Holdsworth professional team. He's not a superior, off-hand kind of bloke, Roy, and he was nonplussed when an ambitious but fairly ordinary rider asked about turning professional.

'Well,' he said, trying to phrase his words tactfully, 'you do have to be quite good.'

Well, with luck you, too, will get to be quite good. There is more chance and more reason to turn professional in Britain than there has been for years. The pros still haven't raised their game enough to have more than one event a day, and usually only then at the weekends, but at least they're not down to barely two dozen riders – which was the case 15 or 20 years ago. There are even more teams on the Continent, and much bigger. But, as Roy said, you do have to be quite good.

So what do you do? Well first you have to let the manager know you're interested. Teams look not for established amateur stars, who by definition are at or over their peak; they look now for promising talent. Make your approach early. Write a straightforward letter to the manager, telling him who you are, what you've done, asking whether he's expanding his team next season, and leaving a day and evening phone number. Or you can make an approach directly or through a member of the team.

Frankly, it doesn't matter how you ask, so long as you ask. Only a prima-donna waits for an approach and that, since the last thing anybody wants is a prima-donna, isn't likely to happen.

It would be silly to say what professionals earn in a year, either from prizes or from retainers. Neither, by even moderate continental standards is large. But you can make a reasonable living halfway up the scale and a

respectable one at the top. You have to remember that however lax the rules are now for prize money in amateur races, there's always more for the professionals. This wasn't always the case, which was rather embarrassing, but the sport's got itself more organised now, and there are professional organisers involved as well.

There's also the fact that there are fewer and fewer top-class amateur races, and trips abroad are no longer moments of great glory. Even if all you were getting was your bike and expenses paid (in other words, the most that even cossetted amateurs would be getting) it would be worthwhile for the standard of racing that you'd enjoy.

Remember, though, that a contract is a legally binding agreement. Sign it and you have accepted obligations in return for your payment. Break it and you could reasonably be sued for the cost involved in replacing you and for general inconvenience.

Take your contract to a solicitor. Great riders have turned professional before by signing contracts balanced on the boots of cars after races – the late Marc de Meyer did precisely that when he joined Freddy Maertens – but don't follow them.

A contract should say not only what you will receive but also for what you'll be paid – is it for starting in races, for finishing, for being a full-time employee of the sponsor? What will those obligations entail? What will happen if you can't get to a race, if you're not willing to make public appearances anywhere in the country, if you make a private deal to appear in one race and your team has signed you for another?

Will most of your pay come in a straightforward retainer, or are you on a small wage and a large results bonus? If it's a results bonus, is it your results that count (in which case there's a disincentive to work for a team leader) or is it the team's?

When and how will the wages be paid? Weekly, monthly, annually? In advance or arrears? What scope is there for increasing or reducing the amount in mid-season? By which of several sponsors are you contracted? If by none of them individually, then by whom? And what happens if one or more withdraw from sponsorship for any reason, especially in mid-season?

They and many others are points that any contracts solicitor will go through with you. You won't regret what it costs. You can even set his charges off against tax, which is another thing to consider.

You can win money in an amateur bike race and it'll be dismissed as the incidental earnings of a hobby, unless there's any suggestion that you're making a contribution to your living at it. Turning professional, though, is an admission that it's your job. Your retainer and your prizes will all interest a tax inspector. Like any other adult, you have to earn a certain

amount after your expenses have been deducted before you start paying tax – but you may have a good season and your expenses, after all, are being paid by the sponsor.

The sponsor will be writing your name and your earnings down as expenditure to reduce his own tax liability, so don't think an intelligent tax inspector won't link things up for himself and wonder why you haven't been declaring.

In addition, you could be responsible for national health contributions and you'd be denied unemployment benefit – something many amateurs claim now. Your car insurance will also rise, because you're a professional sportsman (you'd be silly not to tell the insurance company because (a) it's illegal not to do so, and (b) there's no reason for them to pay out when you crash with a car full of professional bike gear).

All this isn't meant to put you off; it's to let you see that turning professional is a commitment – a professional commitment from which the employer, the employee and the state all expect something. Frankly, considering it's very easy to go back to being an amateur (with the loss of certain privileges, it's true), and bearing in mind the racing is so much better, it's an attractive proposition.

If it appeals, you have only to ask the BCF for a professional licence. It's in their power to deny it, but I doubt they would.

Get off to a decent start and you can raise the amount you want from a transfer to another team. Get off to a worse start and you can, as more and more individuals have done, find yourself a personal backer to help you through. That denies you team support, but it does mean you're still available and catching eyes.

If I was sponsoring a team, I'd be looking not only for someone who could do a good job for me on his bike, I'd be looking for someone who fitted in with everybody else and added to the overall ability of the team – a sprinter, a climber, a good grafter, or maybe just a bloke of ordinary ability but a great sense of humour. But just as much I'd want a rider who always looked smart, who spoke well, who didn't eff and blind at the top of his voice whatever the circumstances, who could talk to reporters and supporters.

As Jack Simes told fellow Americans after turning professional on the Continent:

> A ripped jersey, floppy dirty socks, or unshaved face and legs are not a good advertisement for cycling. If you love the sport you will want to make a good impression on the public and the sponsors by a neat, clean appearance.
>
> It's great to be an individual and do your own thing, but sponsors and

Look quickly and you see a traffic jam. Look again and somewhere there's a bike rider, plugging on glumly. It's not all glamour being a professional, especially in Paris–Roubaix.

promoters are people who treat the sport as a business and they want their workers to be businesslike. American riders who have gone to Europe have learned this overseas, where everybody wants to get a pro contract.

Even in a tiny little criterium, every bum comes to the race looking like a banker because he knows maybe that's going to mean the difference between some kind of contract or not.

That means you don't rant or rave after a race. You accept, as the great Fausto Coppi said, good and bad luck with equal serenity. It also means you help keep the show going. You make yourself available straight away after a race to talk to the commentator, to the radio and TV crews, and to accept your prize from the podium. You're also happy to say a few words of thanks on the public address.

Turning professional abroad is not only harder, it also means that you've got to live there before and afterwards. This often comes as a difficulty for British riders, who are only a few hours away from home wherever they settle in the main cycling countries. That makes it easier to go but also easier to come back. Australians, on the other hand, have already come halfway round the world to have a go and succeed rather more.

That doesn't mean you have to give up like the others. Yes, it is rough being abroad. You can end up living in accommodation which any British council would have condemned. But there's no other way unless you're going over with a loaded wallet.

Let me say now that there's no point in signing for a professional team unless you have a good grasp of the language. Everything you do to get a

foreign contract has to be bigger than a native of the country. Ask yourself: if you were a team manager, would you rather have a local or a foreigner, especially a foreigner who makes you speak a foreign language?

There may have been other reasons why many of the British riders came home after signing for Peter Post's Raleigh team, but the one that he gives are that they didn't fit into the team because of their attitude and because they didn't speak the language.

If you can have a hard time in a Dutch team, where all the riders have English as a second language, how much harder would it be in Belgium, France or Italy? If you're serious about it, learn the language and don't rely on the humpty-back version you'll learn from other bikies.

Then choose the country. Belgium has more teams in relation to its size than any nation on earth. The sponsors change from year to year but the conditions don't. They're good in the best ones, pretty awful in the minor ones. Every year there are court cases alleging non-payment of retainers. Belgians seem even more adept than the British in falling out with one another and having great political arguments. Small Belgian teams are quite open to British riders, although the conditions are rarely attractive.

Dutch teams can be rich or more usually poor, but they have a reputation for being fairly run. All but the biggest are too poor to race further afield than Belgium, though, so you'll probably end up riding criteriums round village squares every other day. The bigger teams have a good choice of Dutchmen, so they're difficult to join.

French teams were until the last five or six years, the exclusive property of Frenchmen. Now they're going the other way. There are so many English speakers in French teams these days that it's the French who feel threatened.

There's a minimum wage in France and you may well end up on it, but conditions are good, the teams have a high reputation, and the sponsors and management take them seriously. Apart from the other Britons, Irish, Americans and Australians, though, you won't hear English being spoken.

French teams are second only to Italian ones in attractiveness. Italian bike teams seem to do nothing by halves, even if they only rarely travel beyond southern France. They pay well, they treat well, and they get very excitable.

Of the others, well I've yet to meet a Briton or American riding for a Spanish, German or Scandinavian team, so I can't tell you. Maybe that's all you need to know.

Do look carefully at any contract you're offered. Remember that it's always negotiable and you're not always going to be offered the best terms a team could go to. But don't be unreasonable in your first professional season.

Wherever you go, by the way, you need only your BCF professional licence. It's valid in all the UCI countries, which means right round the world.

If you want more information about racing as a professional abroad, see the addresses in the previous chapter on racing abroad.

Team management

The chances are that you won't become a professional. As you get towards the end of your racing days, you still have a lot to offer. You'll want to carry on riding, of course. No point in wasting the health and fitness that you've gained and worked for. But there's no point in wasting the experience either.

You might want to consider becoming a coach. The British coaching system has suffered over the years from a chaotic idea of its own importance and the most complicated structure – it's backed jointly by the BCF and RTTC and for a long time, perhaps even to this day, both organisations wanted it to do different things. Even so, it's worth your support. You can get the address of the current secretary from the BCF or RTTC, and from the secretary details of courses and examinations.

You might also like to consider helping the English Schools Cycling Association, bringing youngsters into the sport.

Finally, you might like to consider team management. The BCF always need new experienced, enthusiastic managers for amateur teams and the sport needs fresh managers for its professional teams. It's not impossible to set up a professional team of your own; it's not easy to find backers, but frankly that's all it needs. That and your expertise.

I heard the job described once as being a firm uncle. I suppose it's true. Bike riders are just a bunch of kids. A review of Bernard Thompson's book on the history of time trialling asked: 'Could those heroes we revered really have looked so young?' If you think you can help basically young and inexperienced but enormously tough bike riders through a crisis period of a weekend to three weeks, then team management is for you.

Unless you're a professional manager, you don't get to select the team. It's more likely that *you'll* be changed than one of the riders if it's known that you just don't get on. That said, it's also true that you should be able to be friendly if not matey with most people but also distant enough to earn respect.

The jobs you do depend on the size of the expedition. At the most amateur level, you might be mechanic, masseur and driver as well. Further up, there'll be a separate person for each job.

First you're a man manager. You have to know exactly where each of your riders is at any moment and to know what he should be doing. You have to let the rider know what he's supposed to be doing and you have to have a reason for him to do it. You can't just get a team playing basketball unless you've got a good reason.

It's your job to know:

— Exactly where the start is, how long it will take to get there, when you're due there, and what the starting arrangements are;
— Where the team cars should be parked, whether riders should arrive changed or unchanged and what arrangements there are for luggage in a place-to-place race;
— Who is riding, and as much as you can about the opposition;
— From that information, and what you know about the course, you have to decide which of your team to favour and why and how it'll be done;
— Where any feeding points are along the route and whether individuals have special needs;
— That the mechanic — and the masseur and driver if you have one — is fed, watered and found a bed, that he doesn't have to work all night, and that he has no problems;
— The finish area, tell the riders where you'll be, where they can collect their tracksuits and how far they have to go to their hotel;
— You have to collect the results, handle protests, accept penalties, represent the team at meetings and make sure riders go to celebration dinners.

There's more, of course. And luckily most of the information, in a good race, is contained in the event bible. That's the often bulky book of route maps, profiles and general details supplied to each team.

A stage race is a huge undertaking. However tired you feel, however frustrated, you have to keep the atmosphere sweet. You have to understand the riders, and have them understand that you're not a dogsbody. One difference between riders is the way they react at the finish. Some come in quiet, worn and weary. All they need is a tracksuit, supplied promptly, a warm, wet sponge for their face, and a glass of sweet coffee. Others arrive in a blazing temper, rarely over anything in particular, more usually because they've just got their adrenalin racing.

One doesn't need you more than another. The quiet guy might have been belting his heart out all day, desperate for the finish line and the coffee that means it's all over. At the same time, the hothead has to be calmed down before he goes off and hits somebody.

You take the conventional finishers, let the mechanic or the masseur

take the hothead. That makes it plain that he's not getting special attention just because he shouts a lot.

Sort out those who need to go to the podium, give them clean hats and jerseys, and send them straight there, if possible with a helper to ward off interested spectators. Listen to the others, sort out petty grievances from something which might need to be taken to the race jury, and above all don't let riders shout, argue or handle protests themselves. That's your job.

You may even want to let a rider sleep on it. The Spanish have a proverb that the horns of a bull by night turn into the ears of a donkey by morning – in other words, things sink into perspective.

A lot of strain now falls on the mechanic. Give him a hand while the riders shower and change. Help him hose down the bikes, dry them and stack them away. He can then get round to proper service work and maintenance once he's showered and eaten.

The masseur starts work soon after the meal, taking the team leader first and working down to the last man. That's a good and understandable routine to keep to. It'll take half an hour to massage each rider, listening to their troubles as he goes. Try to avoid getting into discussions about the race and, more importantly, about other members of the team. The masseur may be the rider's friend, but he's also a member of the team management. It's the manager's job to handle the riders and, when things aren't going well and riders start feeling resentful, it's very easy for an unwise word or an honest difference of opinion to cause splits that look chasm-wide to the riders.

Downstairs, usually in a garage or somewhere even more uncomfortable, the mechanic is working. Again he starts on the team leader's bike and works through them all. That way, however tired he gets (and mechanics work the longest hours and sleep least of all), mistakes are never made on the bikes that count. After the team bikes come the service machines. They too have to be checked each evening because they've been shaken about and maybe soaked all day on the roof rack.

And then, at some time of night, the team car or cars have to be taken for re-fuelling.

You have to be dedicated to be a team mechanic. It's a rotten job and you can't do it unless you've got an exceptional sympathy for bicycles – especially other people's. Nobody minds doing their own bike. Who wants a load of others?

You have to listen carefully to what riders want, to the changes that need to be made for the next day. Sometimes, if you know the course, you might be able to suggest gearing alterations more wisely than the rider.

You have to check each machine minutely for cracked cranks, particu-

It takes an odd sort of chap to want to work on other people's bikes all the time. This is Steve Snowling, now a full-time team mechanic – and one of the best.

End of story.

larly around the bottom bracket spindle, pitted headsets, loose or broken spokes, drying tub cement. Everything. On a bad day you might end up building two or three wheels from scratch.

Depending on who you've got with the team, the manager might sometimes help, although more usually his experience will make him a better helper for the masseur. A lot of mechanics can't stand anybody else fiddling with *their* bikes!

The manager should be spending available gaps checking the following day's course and collecting the full result sheet, especially the general classification. Then, when the team's massaged, he can talk to them as a group and discuss tactics. Later, just before they sleep, he'll make his rounds of the hotel rooms just to see if there are individual problems that need to be sorted out.

Then, with the team in bed, he's down with the mechanic to make sure all is well, talking to the masseur about anything he's heard or problems he's detected, making a final check with the race organisation for changes, and then, and only then, has he got time for a drink at the bar. Usually by then it's shut, anyway.

Never lounge about, drink or do anything in front of riders that suggests you're not taking it seriously. You'll have their respect if you're working as hard at it in your way as they are in theirs. Never go anywhere unless the rest of the team management know about it.

You should be first up in the morning, checking again that your hotel breakfasts are what you want and on time. You should send the riders out with the team car in support – that always looks good when the team arrives to sign on again – while you make sure the baggage is organised. Then you, too, go to the start, and another day begins.

Being a masseur is a little like being a mechanic. Again, the chances are that it's the only job you've wanted to do. Mere leg-rubbers aren't wanted. The sport now is looking for qualified masseurs or physiotherapists, who belong to a recognised organisation. You can get details of all these jobs, and how to be considered, from the BCF.

Finally, whatever you do during your racing career and afterwards, remember that however rotten some bits of it might seem, it is by and large a great game. But, because most of it is on ever more busy roads, sometimes roads that are closed to other people at inconvenience to themselves, we can practise it only with other people's sympathy.

They are busy people with worries, interests and pre-occupations of their own. They don't have to say 'Hey, there's a bike race . . . what a great event.' They can have a very different attitude. And it's your attitude which will decide which. Be kind to your sport and it'll be kind to you.

Index